IMAGES
of America

OLD BROOKLYN

IMAGES
of America

OLD BROOKLYN

Historical Society of Old Brooklyn

ARCADIA
PUBLISHING

Published by Arcadia Publishing
Charleston, South Carolina

Library of Congress Control Number: 2013953155

For all general information, please contact Arcadia Publishing:
Telephone 843-853-2070
Fax 843-853-0044
E-mail sales@arcadiapublishing.com
For customer service and orders:
Toll-Free 1-888-313-2665

Visit us on the Internet at www.arcadiapublishing.com

This book is dedicated to the Historical Society of Old Brooklyn members who have kept Old Brooklyn's history alive in the hearts of its people.

CONTENTS

ACKNOWLEDGMENTS

The Historical Society of Old Brooklyn (HSOB) is pleased to have made this book a reality. It will be a valuable resource for former, current, and future residents of Old Brooklyn and the surrounding areas. All images appear courtesy of the Historical Society of Old Brooklyn unless otherwise noted.

Pres. Constance M. Ewazen was instrumental in securing a grant from the Cuyahoga Arts and Culture organization to help with the costs involved in preparing the book.

Thanks go to the following HSOB members for contributing to the process of preparing this book: Constance Ewazen (for securing the grant, writing and typing the captions, working as liaison with Arcadia Publishing, gathering photographs, and coordinating the entire effort); Michael Stachowiak (for scanning the photographs to the exacting requirements of the publisher and scanning pictures from the Cleveland Public Library Photography Collection and the Cleveland State University Memory Project); Lorene Bowles (for writing the chapter and book introductions, the back cover, the acknowledgments, and the newspaper articles requesting pictures from the public); Richard Bowles (for gathering pictures to be scanned, as well as many miscellaneous helps); Carol Lade (for contributing pictures she photographed years ago of Old Brooklyn); and the historical society's other members for contributing photographs.

Gratitude goes to the Cleveland State University Memory Project and the Cleveland Public Library for its photography collection. The gathered and well-maintained number of pictures and histories available for the public's use for personal interest or in studies and projects like this is a treasure. We acknowledge the Encyclopedia of Cleveland History for its assistance with picture captions and the *South Brooklyn* and the *Picturesque South Brooklyn Village* books for their helpful information.

A thank-you goes to community residents who contributed photographs from their private collections to be scanned for use in this book.

We would like to show our appreciation to the family of the late Frank Libal, an Old Brooklyn photographer, who allowed many of his archives to be sold. Thanks go to George Shuba, another local photographer, for helping HSOB to obtain the Libal pictures. Any picture in the book that has no courtesy notation is from the Libal estate.

Thanks go to Tom Collins, who obtained the Pearl Street Savings and Trust Co. photographs, and to Steve Shroka, who gave us the Producers and Deaconess photographs.

The historical society acknowledges Arcadia Publishing for publishing this book. Arcadia deserves great thanks for making it possible to provide Old Brooklyn and communities across the country with these invaluable books that preserve our histories.

Thanks go to anyone else who contributed in any way to the process of readying this book for the publisher.

INTRODUCTION

Old Brooklyn is a neighborhood on the west side of Cleveland, Ohio, located about five miles south of Cleveland's downtown area. Its boundaries east-to-west extend from the Cuyahoga River to the City of Brooklyn and north-to-south from the Brookside Park valley to the city of Parma.

In 1790, Joseph Du Shattar, a fur trader, established a trading post on the bank of the Cuyahoga River across from what became known as the Newburgh section of Cleveland. This was the first European-descent settler in the area of Old Brooklyn.

Originally, Old Brooklyn was an unincorporated part of Brooklyn Township, which covered roughly the area from Lake Erie (north) to Parma (south) and from the Cuyahoga River (east) to what is now about West 117th Street. In 1814, Old Brooklyn became the hamlet of Brighton, centering around the intersection of present-day Pearl and Broadview Roads. Brighton was incorporated as South Brooklyn Village in 1889. It was annexed to the City of Cleveland from about 1905 to 1927.

During the late 1880s, farmers in Old Brooklyn's Schaaf Road area were among the first in this part of the country to use greenhouses to plant and grow vegetables. By the 1920s, the Old Brooklyn neighborhood was one of the nation's leading producers of greenhouse vegetables and had over 100 acres under glass. It was often called the greenhouse capital of the country. Due to the rising costs of gas used to heat the greenhouses, many of them began closing in the 1960s. In their place, new housing appeared, as well as the initial plans for the now-completed Jennings Freeway.

Commercial development in Old Brooklyn peaked between 1920 and the late 1950s. Shopping areas stretched along Pearl, Broadview, Memphis, and State Roads. Later, the development of shopping plazas began at the intersections of Pearl and Brookpark Roads, Broadview and Brookpark Roads, and Memphis and Fulton Roads.

Residential construction blossomed from early in the 20th century to the 1950s. Then, in the 1980s and 1990s, there was a new burst of residential growth in the South Hills (near Broadview and Spring Roads) and in the Jennings Road area. Housing values in Old Brooklyn are considerably above average for the Cleveland area.

Old Brooklyn's most well-known landmark is the Cleveland Metroparks Zoo, which moved to Old Brooklyn in 1907 from its former home on the east side of Cleveland near the area called University Circle. Cleveland's park board was instrumental in moving the zoo to Brookside Park, located in the Big Creek valley area of Old Brooklyn. The 145-acre park lies entirely within Old Brooklyn and is one of the 16 nature preserve reservations of the Cleveland Metroparks System.

In October 1915, Brookside Park became a notable part of sports history when it hosted what is thought to be the largest baseball crowd in Cleveland history, with about 115,000 spectators cheering as the home team, White Autos, beat the team from Omaha in the World Amateur Baseball Championship.

The Jeremiah Gates Home, built in 1820 and located at 3506 Memphis Avenue, is believed to

be the oldest home in Old Brooklyn. Other landmarks include the Brooklyn-Brighton Bridge, the Estabrook Recreation Center, the Benjamin Franklin School Gardens, and the former Deaconess Hospital (originally known as Evangelical Deaconess Hospital), now a part of the MetroHealth system. Old Brooklyn also has an abundance of historic old churches of numerous denominations that still serve local congregations.

James Ford Rhodes is the only secondary school within Old Brooklyn. Some of its well-known graduates include Drew Carey, the television star; Les Horvath, winner of the 1944 Heisman Trophy; and Mary Strassmeyer, a columnist for the *Cleveland Plain Dealer* and the *Cleveland News*.

Old Brooklyn has had an active historical society since 1982, though it does not, as of yet, have its own museum. The society participates in many community activities by providing displays, having historical programs, and including articles in the local newspapers. In 2011, the Historical Society of Old Brooklyn published its first book, *Speaking of Old Brooklyn . . .*, a compilation of 40 oral histories from elderly people and local business owners.

Old Brooklyn includes all of Cleveland's Ward 13, as well as a portion of Ward 12. According to the 2010 census, Old Brooklyn's population was 32,009.

Future developments include the Treadway Creek Greenway Restoration project, which is intended to restore and preserve 208 acres of land, as well as to open space along Treadway Creek. The project includes forging a trail connecting the neighborhood to the Ohio & Erie Canal National Heritage Corridor's Towpath Trail. Plans also include a possible connection in the trail that would link the Big Creek Reservation with the Cleveland Metroparks Zoo.

Old Brooklyn's present boundaries include the Brooklyn-Brighton Bridge to the north, Brookpark Road (Parma's northern border) to the south, the Jennings Freeway (State Route 176) to the east, and Ridge Road to the west, though this boundary is uneven and is shared with the City of Brooklyn. Its southeast corner also shares a small boundary with Brooklyn Heights.

Old Brooklyn was for many years—and still is—a vibrant community, a great place to live and work and worship and play.

One

NEIGHBORS

The beautiful homes and churches, as well as the abundance of greenery, made Old Brooklyn a popular place for early settlers to call home.

However, it was the people of Old Brooklyn who made it a warm and friendly neighborhood. It offered interesting and hardworking folks who made a difference in life both here and across the general area. Residents included the likes of doctors, pastors, educators, politicians, business owners, lodge members, undertakers, military veterans, and more. For example, there are Civil War veterans in Old Brooklyn cemeteries, and these veterans are honored every year.

Fred R. Mathews served as the mayor of South Brooklyn at the time it was annexed to the City of Cleveland in 1905. Dr. Samuel J. Webster, whose home and office still beautify Schaaf Road, served as a doctor for seven decades, delivering more than 5,000 babies and serving more than 51,000 patients over the years, as well as being involved in many other areas of doctoring.

Several undertakers, including the Busch family and the Wischmeier family, helped people bury their loved ones, and florists, including Karl Witthuhn, were here to prepare lovely arrangements. Karl Witthuhn's business was taken over by his daughters upon his retirement, and the fourth-generation Speed and Young family members are now running the Speed Exterminating Company. The original Speed-Young homestead is still standing on Valley Road.

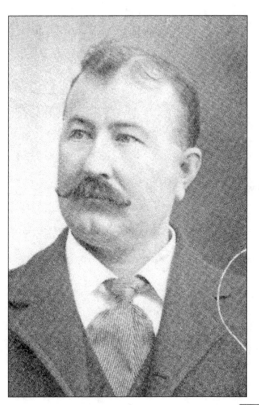

Fred R. Mathews (1867–1915) was mayor of South Brooklyn Village during the time of its annexation to Cleveland in 1905. He was married to Mary S. (1859–1921). Fred was manager of the South Brooklyn Coal Company, and his home was located at 3510 Muriel Avenue. South Brooklyn's first mayor was George Guscott, who lived on Broadview Road, and the first clerk was Ora J. Fish. Guscott served as mayor for four years. Guscott was followed by H.H. (Ham) Bratton, and he by Lyon Phelps, James Rodgers, and Fred Mathews. (Courtesy of *Picturesque South Brooklyn Village*, by Thomas A. Knight.)

George W. Bader (1863–1950) and his wife, Allie M. Foster Bader (1874–1931), were married on August 4, 1896. They had eight children. George was the youngest son of Johann Christian Bader (1805–1888) and his wife, Dorothea Orth Bader (1821–1904). He inherited the farm from Johann, and it was located on what is now Bader Avenue. George Bader is buried in Brooklyn Heights Cemetery. (Courtesy of Claudia Bader.)

Allie M. Foster Bader (1874–1931) was the daughter of Jacob Foster and Frances Krewson. Her paternal grandparents, the Krewsons, raised her. Allie married George W. Bader in 1896, and they had nine children, including a baby girl who died the day she was born. Allie is buried in Brooklyn Heights Cemetery. (Courtesy of Claudia Bader.)

Otto Sell was a baker by trade when he came here from Germany. He ran this store for many years with help from the community. He was, for many years, the "all-around" good grocer. His store was located where the Francis Frock store once was.

Samuel J. Webster was born on October 26, 1875, and died April 11, 1969. He began his medical practice in the early days by applying leeches, using acupuncture, bleeding patients, and treating typhoid fever by immersing patients in ice-cold full-tub baths. He graduated from Western Reserve Medical School in 1896. In 1919, representatives of a religious group from St. Louis bought the Johnson farm in Brooklyn, next door to Webster's office on Pearl Street. The Evangelical Deaconess Hospital (later known as just Deaconess Hospital) developed with Dr. Webster's advice on the selection of professional leadership and the choice of a head surgeon. The hospital was opened in 1923, and patients were first served in the old Johnson farmhouse before a hospital building was erected in 1925. In 1937, he went on to become an internal medicine specialist. He served as chief of medical services from 1928 to 1950. Dr. Webster delivered over 5,000 babies in his career. (Courtesy of Jill Riegelmayer Kolodny.)

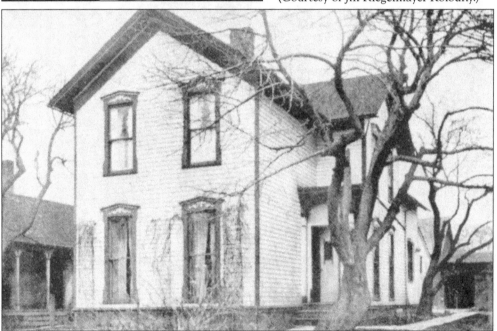

Dr. Washington E. Linden purchased the pictured property at 3444 Memphis (formerly 22 Linndale) Avenue from Charles Gates in 1895. His practice was above Bader Drugstore on the corner of Pearl Road and Brookmere Avenue. His son John Linden, MD, was one of the founders of Deaconess Hospital. (Courtesy of *Picturesque South Brooklyn Village*, by Thomas A. Knight.)

Cleveland firefighter August Friedrick Christian (1880–1917, left) was appointed to his job on April 4, 1901. His brother Henry Christian (right) was a policeman. These brothers lived at 3117 Searsdale Avenue and came to Cleveland from Germany and swore allegiance to America. This picture was taken in 1904. (Courtesy of Chuck Christian.)

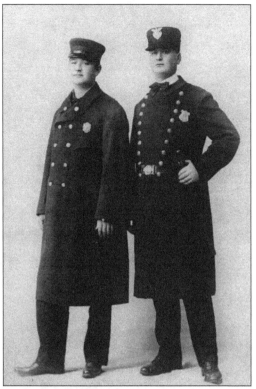

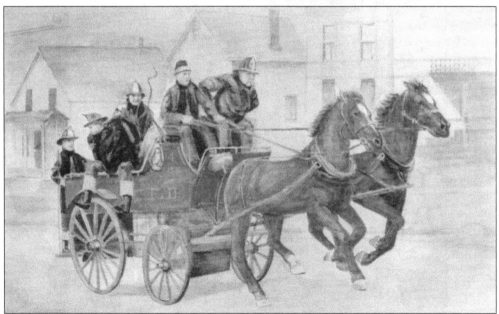

This painting of a horse-drawn fire engine was created by Janice Uhinck Hunt, granddaughter of an original South Brooklyn fireman, from the town hall firehouse on Broadview Road. Janice Uhinck Hunt was the daughter of Fred Uhinck, the man who sold his hardware store to Jack Wygonski, the owner of the original South Hills Hardware on Broadview Road. (Courtesy of Carol Lade.)

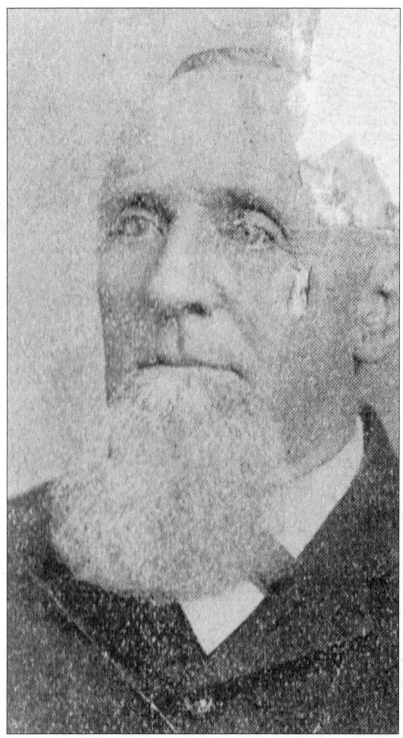

A post office was established in Brighton in 1836. Charles Huhn was the eighth postmaster and owner of Huhn's Hall on Broadview Road. Charles Huhn's son Carl Huhn was the area's first undertaker. He was the business partner of Henry Froelich.

Lizzie Huhn Froelich, Jessa Huhn, and Barbara Huhn were Charles Huhn's daughters. He also had a son, Carl, who was the undertaker, who lived on Alvin Avenue. Lizzie married Henry Froelich, her father's partner at the general store, with whom she had children Carl, Alma, Elsie, Edwin, and George. When Lizzie died, Henry married her sister Barbara. Henry Froelich is buried with both of his wives in the Brookmere Cemetery.

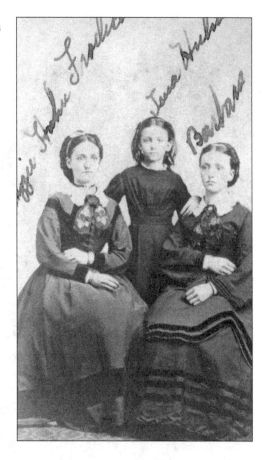

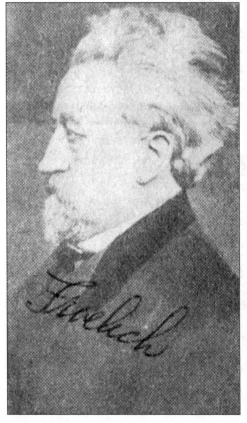

Son of Jacob and Sophie Froehlich, Henry Froehlich was born March 10, 1848, at 7095 Broadview Road. Henry died in this same home on March 21, 1930. During the Civil War, this house was a stop on the Underground Railroad. At age 14, Henry enlisted in the Union army as a musician and went on to become the youngest soldier in the 107th Ohio Volunteer Infantry. In 1870, Henry returned home and established Froehlich General Store, where he also provided mail service and funeral arrangements. The store sat at the corner of Pearl Road and Krather Avenue, but later, it was moved to the site of the Broadvue Theater. Henry also served as the first postmaster of South Brooklyn and was a member of the village council, the president of the South Brooklyn Board of Education, and the first mayor of Seven Hills.

In 1920, Karl K. Witthuhn (1894–1956) originally established his business where the South Brooklyn Post Office is now, and then he moved the shop to Brooklyn Avenue. (Both, courtesy of Louise Witthuhn Evans.)

Martin L. Ruetenik is pictured on March 20, 1929. Martin was the past president of the Market Growers Association and was the owner of a greenhouse on Schaaf Road. The South Brooklyn community was an important market-gardening center for generations. Gustave Ruetenik & Sons made a milestone in South Brooklyn gardening history when they introduced greenhouse gardening in 1887. Martin was Gustave's brother. (Courtesy of the *Cleveland Press* Collection, Michael Schwartz Library, Cleveland State University.)

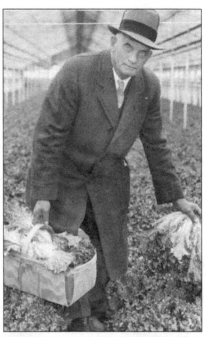

Karl J. Hopp is standing in front of the rustic garden shelter at the Benjamin Franklin School Gardens. He is shown here working on the landscape outside of the rustic garden shelter that was designed by Raymond Pershe, who was later named city forester for Cleveland, Ohio. (Courtesy of the *Cleveland Press* Collection, Michael Schwartz Library, Cleveland State University.)

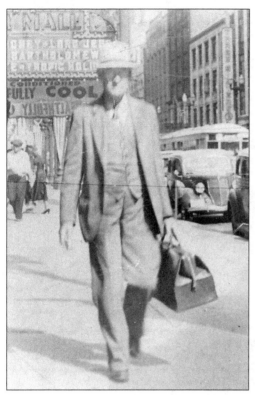

John Warren Speed was the founder of Speed Exterminating, now located at 4141 Pearl Road. John was employed by the Rose Exterminating Company in Cincinnati, Ohio, where he had been trained in the pest-control industry. In 1907, the company sent him to Cleveland to open a branch at East Second Street and Prospect Avenue. In 1908, John decided to begin his own business, establishing the J.W. Speed Rat and Insect Exterminator Company. (Both, courtesy of John Warren Young.)

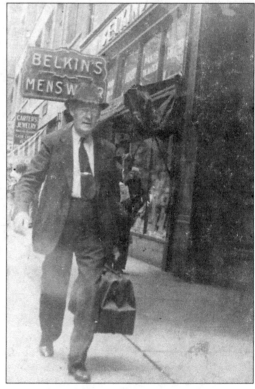

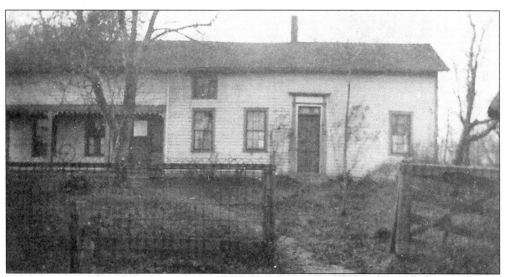

The home of John Warren Speed was located at 4080 Valley Road. This image portrays the house when it was purchased in October 1918, before remodeling. Riley Brainard built the home in 1840. (Courtesy of John Warren Young.)

The pastor of St. Luke's Church from 1865 to 1876 was Rev. F. Schroeck, and under his leadership, the church became a member of the German Evangelical Synod. (Courtesy of Pastor Gerald Madasz.)

Mrs. Schroeck was Pastor F. Schroeck's wife. They lived in the "new" Collister house. (Courtesy of Pastor Gerald Madasz.)

Rev. J.J. Walker (1850–1912) was the first pastor of St. Mark Evangelical Lutheran Church. In the spring of 1893, Pastor J.J. Walker of St. Matthew Lutheran Church began to hold services on every fourth Sunday in the home of Leopold Lucht at 3304 Roanoke Avenue; the house is still standing. A plan was discussed with the pastors of Christ, Immanuel, St. Matthew, and Trinity Lutheran Churches, whose donations and encouragement prompted the members of the South Brooklyn Mission to go ahead with the building of it's first house of worship. A contract was drawn with Charles Gates to proceed with the building of a small church. In the fall of 1893, the little church was completed. This little church is still standing at 3214 Ruby Avenue. (Courtesy of St. Mark Lutheran Church.)

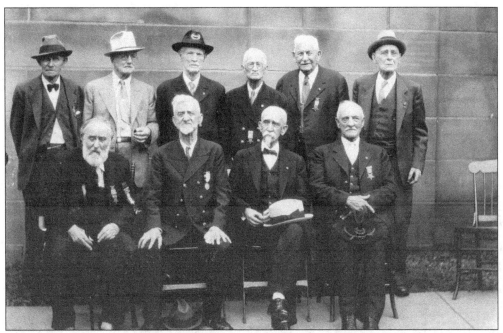

This is the only image the historical society has of South Brooklyn's Civil War veterans. These men would have assembled at Camp Cleveland in the Tremont neighborhood. Some of their graves can been found at Brooklyn Union Burial Ground, located at the corner of Broadview and Spring Roads, in Brookmere Cemetery and Riverside Cemetery.

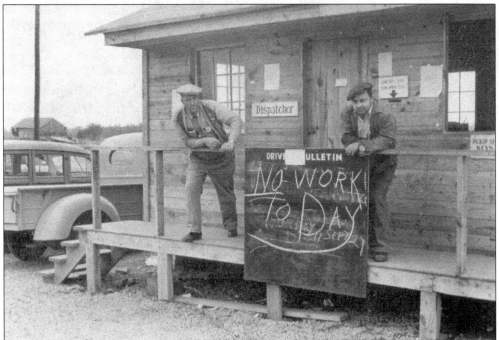

Old Brooklyn faced hardships during the Great Depression, much like the rest of the country. In this image, two gentlemen stand outside a dispatcher cabin, discouraged by the lack of work available. Many people struggled to provide for their families.

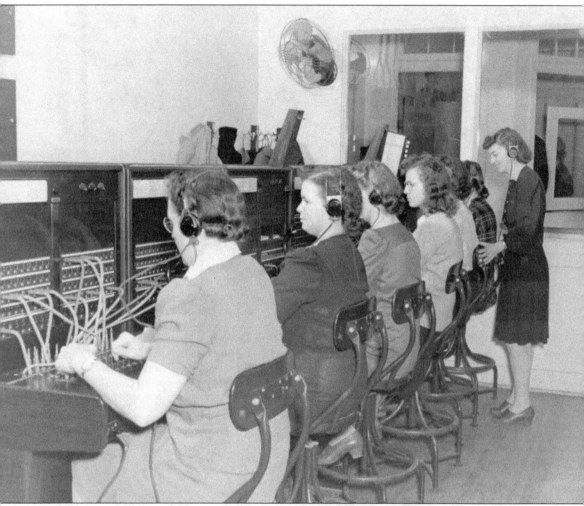

This photograph shows the private branch exchange (PBX) switchboard operators. Operators were used until 1940 at Ohio Bell on 4314 West Thirty-fifth Street (State Road). This exchange building, Shadyside, was erected in 1926.

Two

BUILDINGS

The buildings and structures of Old Brooklyn include businesses, schools, funeral homes, homes of prominent early settlers, and the bridge in its various stages.

One will find businesses and funeral homes that have been here for many years, some currently being run by third- and fourth-generation family members of the original owners.

Pictures of the early schools are included in this chapter. Some schools have been torn down, but others are still operating, having been renovated over the years.

The building that housed the fire station, police department, jail, and mayor's office, as well as other offices, in the early years of the community is still standing; however, its facade is no longer exactly the same.

The structures that housed the doctors, the grocers, the hardware stores, the florists, and other businesses helped to establish the community as a well-rounded one.

The Brooklyn-Brighton Bridge is pictured in various time periods, from when it was just a wooden bridge over the creek in the valley to its current form as a four-lane major thoroughfare.

While there are many other buildings that were here, this is a good representation of the ones that made Old Brooklyn a great place to live.

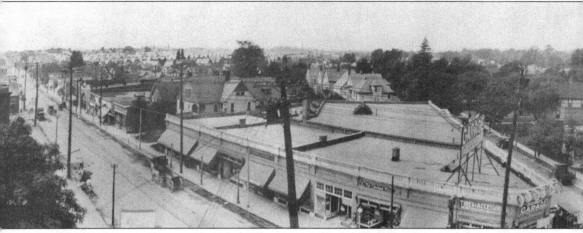

This panoramic photograph, titled "The Heart of South Brooklyn," was taken in 1921 at the intersection of Pearl Road and Memphis Avenue, looking west. Please note that the Glenn

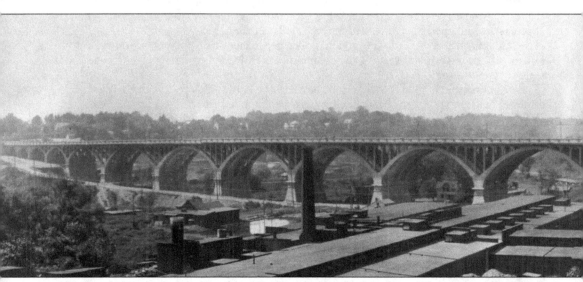

This is a 1920s view of the Brooklyn-Brighton Bridge, looking west. This concrete bridge was built in 1916. The 2,265-foot span had a 76-foot-wide roadway. Two streetcar tracks ran along the

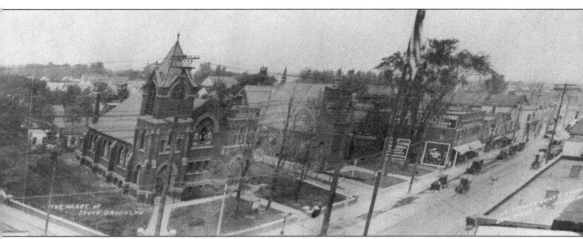

Restaurant was a tire store, and the Greenline Building had not been constructed yet. (Courtesy of Michael Loizos.)

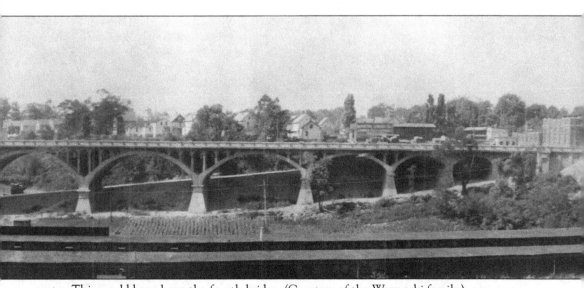

center. This would have been the fourth bridge. (Courtesy of the Wygonski family.)

The third Brooklyn-Brighton Bridge was a steel bridge that lasted from 1897 to 1915. The span consisted of a bridge 1,540 feet in length with a 29.5-foot roadway and 7-foot-wide sidewalks on either side. The road surface was wooden planking.

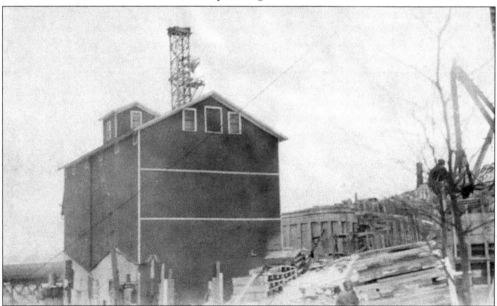

Howard C. Gates constructed the Gates Elevator and Mills Company building in 1893; the Pearl Road entrance to Brookside Park now covers the site of the structure. When the second high-level bridge was built, the structure that housed the elevator and mill was moved down into the valley to make way for the new steel bridge.

The Jeremiah Gates Home, built in 1820, is located at 3506 Memphis Avenue; it is believed to be the oldest residence in Old Brooklyn. Jeremiah and his brother Nathaniel owned and operated a sawmill. Jeremiah lived from 1795 to 1870. He and his wife, Phebe (1795–1881), are buried at Brookmere Cemetery. (Courtesy of Carol Lade.)

The home of Howard C. Gates at 4248 West Thirty-fifth Street (formerly Gates Avenue) was built in 1894. Howard lived from 1851 to 1926. This was also the home of Ella Estabrook, who purchased it from Howard Gates on June 25, 1917. This property is now the Brooklyn House, which has been a home for the developmentally disabled since 1996. (Courtesy of Carol Lade.)

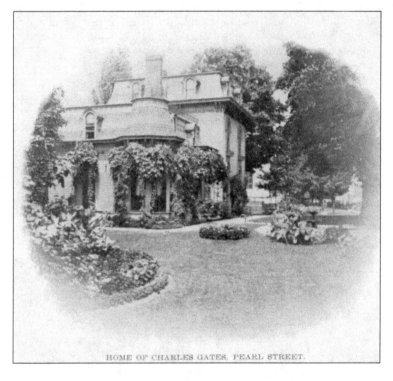

HOME OF CHARLES GATES, PEARL STREET.

Charles Gates (1825–1907) lived on the corner of Memphis Avenue and Pearl Road. Charles Gates was the father of Howard C. Gates. The picture of the home was from 1893. The house was on the location of the present CVS Pharmacy, the former location of Glenn Restaurant. Charles is buried in Brookmere Cemetery, in the southwest corner, alongside his wife, Mary, surrounded by his family.

The Glenn Restaurant was established in 1926 and was taken over by the Loizos family in 1946. Its location in the heart of Old Brooklyn made it central to many neighborhood gatherings, as well as a dining place directly across from Deaconess Hospital. The restaurant is pictured here on the corner of Memphis Avenue and Pearl Road in 1983. (Both, courtesy of Carol Lade.)

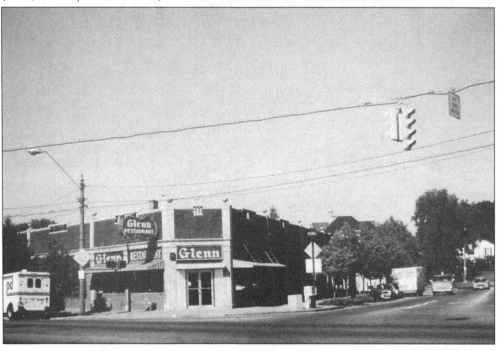

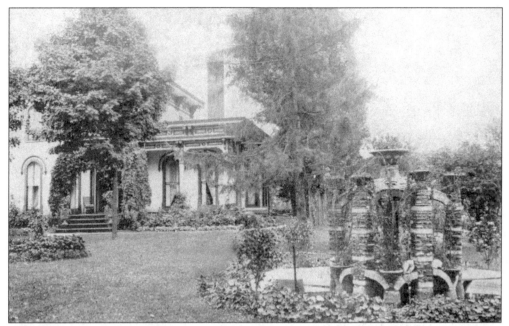

According to Richard L. Bowles of the Historical Society of Old Brooklyn, John L. Johnson built this residence in 1893. This property later became Deaconess Hospital, and the home itself was actually the original site of the nurses' residence. Johnson was born in the state of New York on February 20, 1825, but his family moved to South Brooklyn in 1836. He married Angenette Acker in 1847. In 1850, Johnson left Ohio to mine gold in California. He returned to his wife in 1852, with gold turned to cash, and took up farming. In 1861, he turned to the mercantile business, opening a general merchandise store on the southeast corner of Pearl and Broadview Roads. He operated the store for 24 years before retiring in 1885, just before the area became incorporated as South Brooklyn. John L. Johnson also served as a township trustee. He died in 1911 and is buried in Brookmere Cemetery.

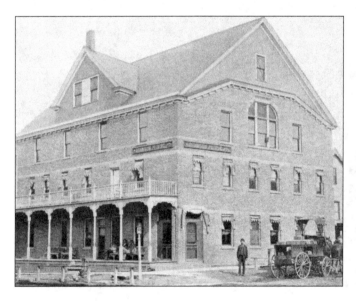

In 1890, John L. Johnson built the Johnson House Hotel, a multilevel hotel and eatery, on the northeast corner of Broadview and Pearl Roads. The Johnson House Hotel was the overnight stopping place for farmers en route north to Cleveland markets to sell their produce; it also offered a resting place to the mules and horses carting the goods before crossing the Big Creek Valley. (Courtesy of *Picturesque South Brooklyn Village*, by Thomas A. Knight.)

Dr. Samuel J. Webster's home was located on 1617 West Schaaf Road. Dr. Webster moved to this home after his home on the site of Deaconess Hospital was taken. He had his practice in this home until he retired. (Courtesy of Jill Riegelmayer Kolodny.)

This home was located at 4264 Jennings Road and was originally the home of Ebenezer Fish on land purchased on May 11, 1826. The home remained in the family until it was taken for the Interstate 176 Highway. (Courtesy of Carol Lade.)

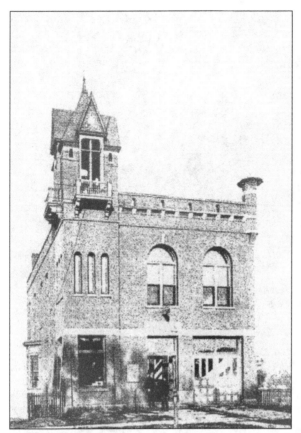

The former South Brooklyn Fire Station at 2310 Broadview Road was built in 1898. The building not only housed the fire department, but also the town hall, which hosted the village council, mayor's office, jail, and police department. (Courtesy of *Picturesque South Brooklyn Village*, by Thomas A. Knight.)

Otto Sell was a baker by trade when he came here from Germany. He ran this store for many years with help from the community. This photograph was taken during the horse-and-buggy days. The store was located where the Francis Frock shop stood, just south of the Woolworth five-and-dime store. The present business in that location is the Top of the Line barbershop.

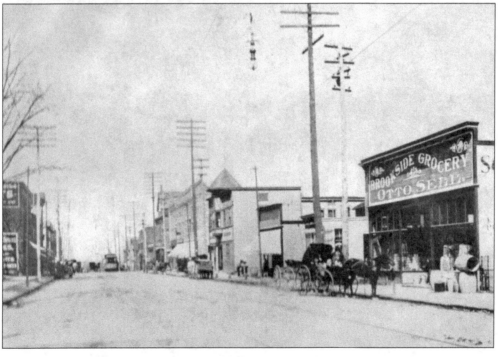

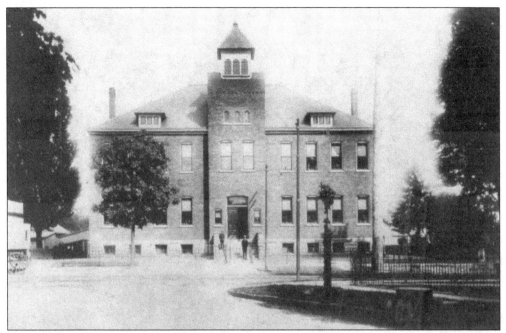

The second Pearl Street School was erected in 1886, opposite Memphis Avenue. It had five rooms, two on each of the lower stories, and a double room on the third floor. The school that was known as the third Pearl Street School was really the second school torn down and rebuilt. This building was abandoned in 1932 and torn down in 1936. Charter One Bank is now on this site.

James Ford Rhodes High School is the only secondary school in all of Old Brooklyn. The school was named in honor of the Cleveland industrialist and historian James Ford Rhodes (1848–1927). James Ford Rhodes High School was opened on February 1, 1932, at 5100 Biddulph Avenue. It is now part of the Cleveland Metropolitan School District. James Ford Rhodes is buried in Riverside Cemetery. The Biddulph family is buried in Brookmere Cemetery. (Courtesy of Carol Lade.)

Charles A. Mooney Junior High School at 3213 Montclair Avenue was built in 1964. When it opened, the school boasted having its own planetarium and greenhouse on the top floor. Charles Anthony Mooney (January 5, 1879–May 29, 1931) was a five-term US representative from Ohio. It is part of the Cleveland Metropolitan School District. (Courtesy of Carol Lade.)

This photograph of Dawning School was received on Founders Day, February 16, 1977. This structure, located on the site of the original 1902 Dawning School, was built in 1913. At one time, the school housed Southern Ohio College. Later, it housed Old Brooklyn Montessori School, which became Constellation Community School; it serves kindergarten through eighth grade.

Memphis Elementary School at 4103 Memphis Avenue, at West Forty-first Street, was built in 1919. It was constructed with fireproof bricks, which separated the classrooms in an effort to contain a fire if it broke out in a particular room. The building was razed in 2012. (Courtesy of Carol Lade.)

William Cullen Bryant School was built in 1930 at 3121 Oak Park Avenue. The school was named after William Cullen Bryant (November 3, 1794–June 12, 1878), an American romantic poet, journalist, and longtime editor of the *New York Evening Post*. (Courtesy of Carol Lade.)

Benjamin Franklin School was erected in 1923 at 1905 Spring Road. The building and grounds cover a land area greater than any other school in Old Brooklyn. Almost half of the grounds were devoted to school gardens. The gardens are now home to the Old Brooklyn Community Gardens. (Courtesy of Carol Lade.)

Griswold Institute High School was purchased to serve as an alternative to the upheaval that took place in the Cleveland Public School System in 1979 as a result of court-ordered desegregation. An elementary school, the Freedom Academy, was added to the high school to provide an option for younger children. In a short period, the schools came to be seen as an alternative for those dissatisfied with public schools for a variety of reasons, not only for desegregation. By 1985, one-third of the students came from school districts other than the city of Cleveland. The campus of Griswold Institute High School and Freedom Academy was located at 6000 Memphis Avenue. In 1946, this school originally opened as Mark Twain School. (Courtesy of Carol Lade.)

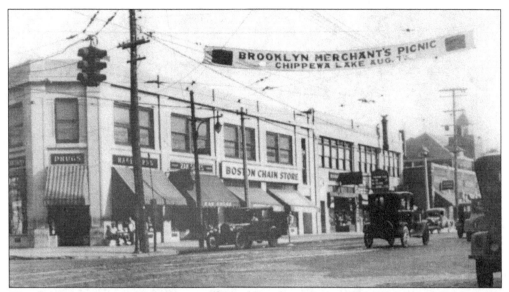

The southeast corner of Broadview and Pearl Roads is seen in 1929. The corner begins with Hagedorn's Drugs at 4179 Pearl Road, which was at that location from 1924 to 1968. Zak Shoes was located at 4181 Pearl Road in 1929. Boston Chain Store was located at 4183 Pearl Road from 1929 to 1931. On the far right, one could see the top of Pearl Street School. Strung across the street is a banner advertising the Brooklyn Merchant's Picnic, which was to take place on August 7, 1929, at Chippewa Lake. (Courtesy of the Cleveland Public Library.)

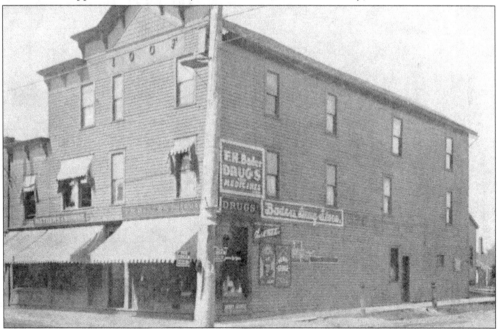

The Bader Drugstore was located on the southwest corner of Pearl Road and Brookmere Avenue. The original drugstore was Schmitt's Pharmacy, operated by Carl Schmitt. Then it was the first South Brooklyn store owned by F.H. Bader. The second floor was where Dr. Washington E. Linden had his practice, and the third floor was where the Independent Order of Odd Fellows met. (Courtesy of *Picturesque South Brooklyn Village*, by Thomas A. Knight.)

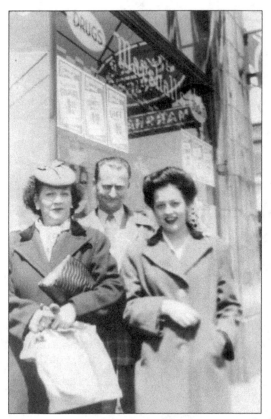

Two customers and the manager of the Marshall Drug Co. stand outside the location that followed Bader Drugstore on the southwest corner of Pearl and Broadview Roads. (Courtesy of Gail Hanks.)

Busch's Prescription Pharmacy was located at 2147 Broadview Road. Oliver Busch opened a drugstore on the southwest corner of Broadview Road and Searsdale Avenue when Mr. Scott (the previous pharmacist) retired. Mr. Busch was more than a pharmacist; he was also a friend who was interested in a family's welfare. Since many people had no health insurance, they relied a great deal on the advice they received from their pharmacists. Busch Pharmacy also had a soda fountain. This photograph is dated March 12, 1968. (Courtesy of the Cleveland Public Library.)

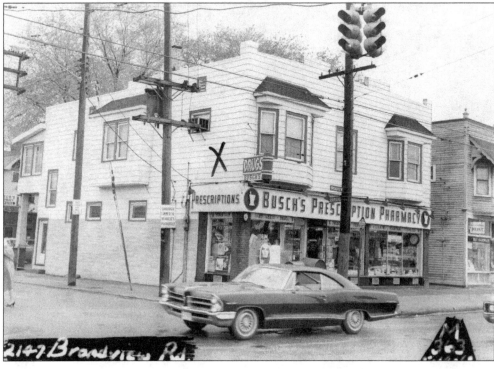

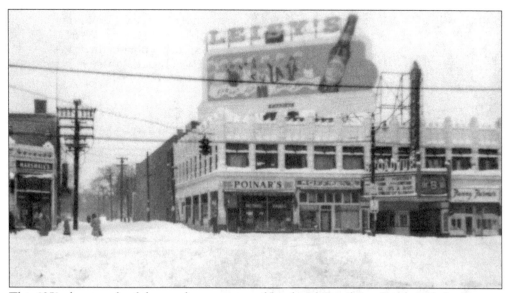

This 1951 photograph of the northwest corner of Pearl and Broadview Roads includes Poinars, a record and radio store; Hoffman's; the Broadvue Theater; and Fannie Farmers, a candy store. The theater was located at 4172 Pearl Road from January 15, 1927 to 1987. The Broadvue was originally a vaudeville/neighborhood movie theater and had a coffered ceiling with a dome in the center. All the seats were on the main floor, and there was no balcony. The Broadvue Theater was demolished in 1992.

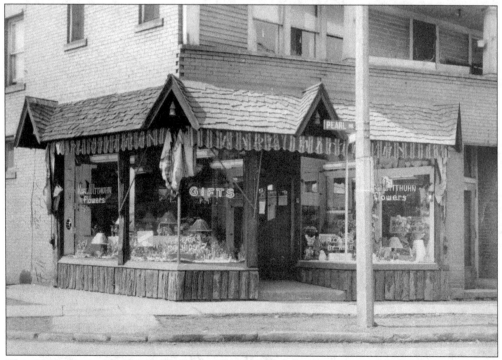

This 1925 photograph shows Witthuhn Florist Shop, which was owned by Karl K. Witthuhn. The shop was located on the corner of Pearl Road and Brooklyn Avenue. (Courtesy of Louise Witthuhn Evans.)

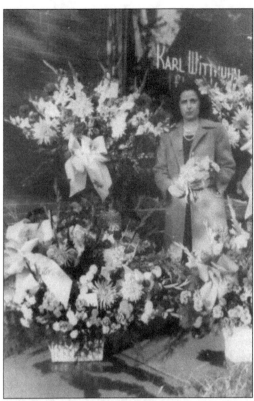

Pictured is an employee of Witthuhn Flower Shop with several flower arrangements in front of the shop. (Courtesy of Louise Witthuhn Evans.)

The South Hills Hardware operated at this location on Broadview Road from 1948 until 2000, when the new South Hills Hardware reopened on Schaaf Road. Jack Wygonski purchased it in 1948 from Fred Uhinck, and his son Jack Wygonski now owns it. (Courtesy of the Wygonski family.)

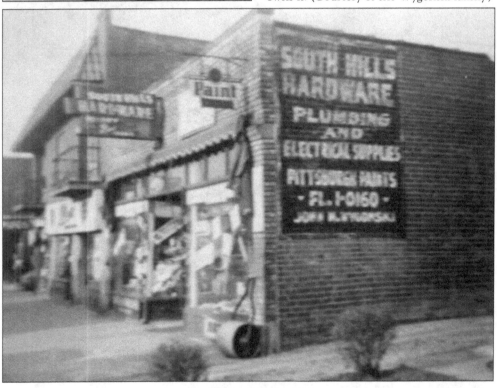

In 1898, William Wischmeier incorporated Wischmeier-Linderman. Then, in 1922, William Wischmeier changed the name to William Wischmeier & Son, the son being Elmer Wischmeier, the grandfather of the William who runs it today. In 1973, they moved the Wischmeier Funeral Home to 3111 Broadview Road. (Courtesy of Carol Lade.)

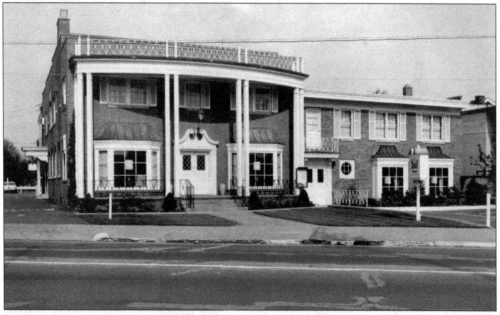

In 1905, Gustav H. Busch opened the Rehburg-Busch Furniture and Hardware Store in the Old Brooklyn neighborhood of Cleveland. The store produced crafted furniture and, typical of that period, built fine wooden caskets; it also had embalming facilities. In 1925, the Busch family was the first to build a funeral home, located at 4334 Pearl Road, to be used only for funeral services. (Courtesy of Carol Lade.)

The Greenline Building at 3426 Memphis Avenue, located on the corner of Memphis Avenue and Pearl Road, was constructed in 1925. In 1926, motor coaches were in use on Cleveland streets, and shortly thereafter, a bus line called the Greenline extended on Memphis Avenue from Broadview and Pearl Roads to Ridge Road, a distance of about three miles. (Courtesy of Carol Lade.)

This Cleveland Transit car No. 163 was at the split of West Thirty-fifth Street (State Road) and Pearl Road, headed toward Public Square, on July 10, 1951. This car was leaving the carbarn, which was located between the wye of these two streets; the carbarn was where the streetcars received their necessary maintenance. (Courtesy of Gregory J. Noeth)

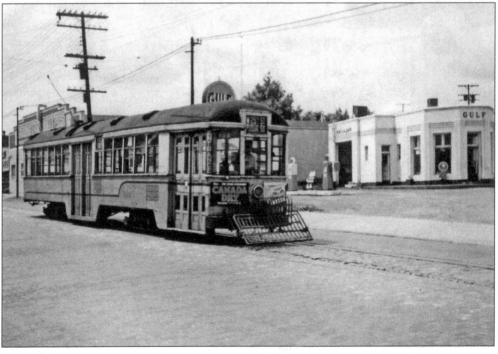

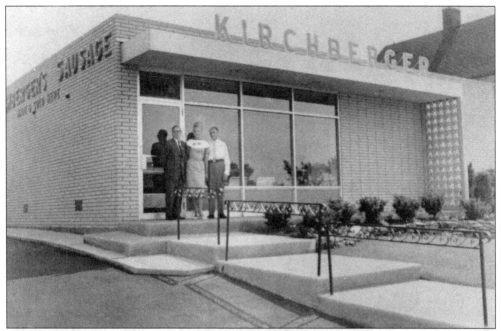

Pictured above in September 1962 are Hans Kirchberger; his wife, Elly Kirchberger; and brother-in-law Thel Johanni. On March 3, 1938, Hans Kirchberger began Kirchberger Sausage. In October 1974, Norm Heinle purchased the business, located at 4501 Memphis Avenue. (Courtesy of the Sausage Shoppe.)

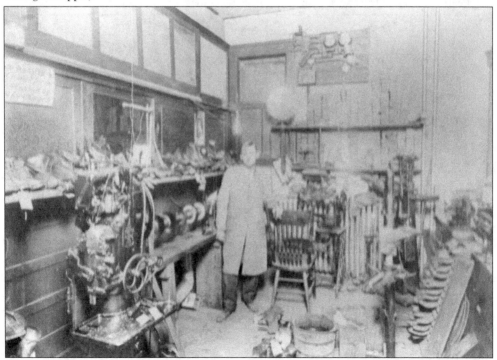

This is believed to be the interior of Guth's Shoe Repair Shop, which was near the corner of Broadview Road and Colburn Avenue.

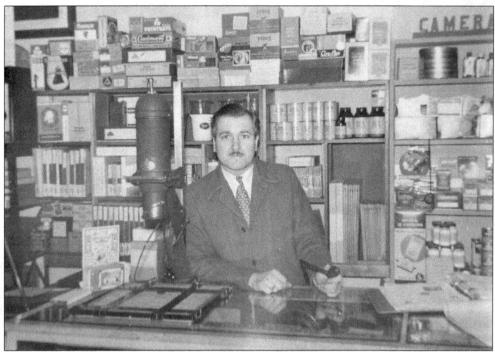

Frank Libal lived from May 23, 1910, to October 31, 1983. He married Doris E. Green. He was the owner of United Photo, near the convenient store along Pearl Road, where Leopold Avenue and Pearl Road met. He was also one of Old Brooklyn's local historians of his time.

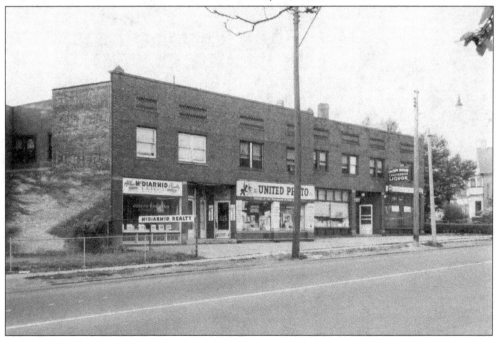

The original location of United Photo was near Cecilia Avenue on Pearl Road. The owner was Frank J. Libal. The last location of United Photo was on the corner of Pearl Road and Dawning Avenue. One could purchase photograph equipment at United Photo as well as film and flashbulbs.

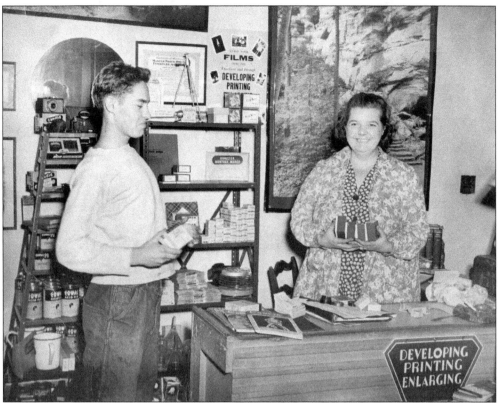

Doris Libal was Frank Libal's wife, and she served customers in the photograph shop also.

There was a cyclone that went through South Brooklyn on April 21, 1909. Not only did the cyclone destroy this house and others in South Brooklyn, but it also took the roofs off St. Mark Lutheran Church and its schoolhouse on Ruby Avenue. This is what motivated the congregation of St. Mark Evangelical Lutheran Church to rebuild on Pearl Road. (Courtesy of Walter C. Leedy, Special Collections, Michael Schwartz Library, Cleveland State University.)

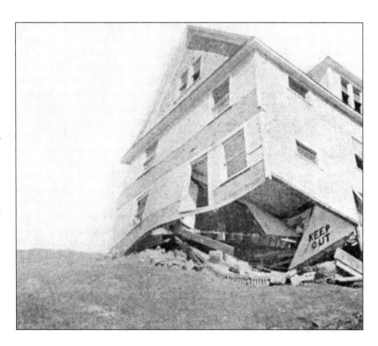

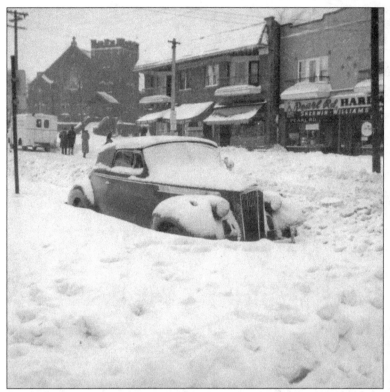

Taken after the five-day 1950 Thanksgiving blizzard, this photograph shows Pearl Road with the front of Unity Evangelical Lutheran Church to the left. An Arctic air mass lowered temperatures to seven degrees. The next day, November 24, low pressure from Virginia moved into Ohio, causing a blizzard with high winds and heavy snow. The storm produced 22.1 inches of snow.

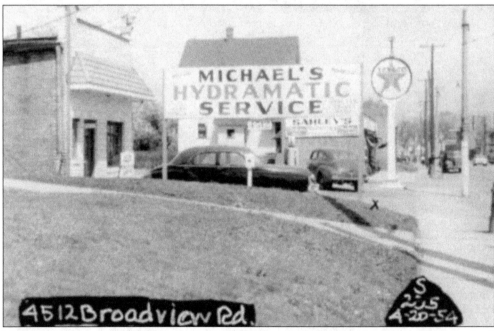

Michael's Hydramatic Service was located at 4512 Broadview Road and is pictured here on April 20, 1954. The Hydramatic was the first fully automatic mass-produced transmission developed for passenger automobile use. It was introduced in 1939 for the 1940 cars. (Courtesy of the Cleveland Public Library, Photography Collection.)

Three

HOUSES OF WORSHIP

As was true of most early communities, the houses of worship in Old Brooklyn helped to form the conscience of the people who lived in the surrounding areas. They were well attended and provided not only worship services, but also fellowship gatherings, recreational opportunities, youth group activities, places of meeting for various organizations, and a host of other functions within the community.

One of Old Brooklyn's earliest churches was the Brighton Methodist Episcopal Church, now the Pearl Road United Methodist Church. This church was built in the 1890s. In 1925, it was destroyed by fire. The members, thereafter, worshiped in their education building—and still do. In the pictures in this chapter, the original church was in the place where the front lawn now is located.

Many of the older churches still retain their Old World craftsmanship and beauty and are living legacies of the significance church life once had in the lives of the people.

Broadview Baptist Church is located at 4505 Broadview Road. (Courtesy of Carol Lade.)

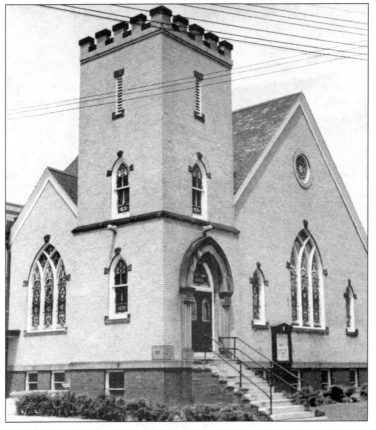

Brooklyn United Presbyterian Church evolved from The First United Presbyterian Church of Cleveland, located at Carnegie Avenue and East Seventy-ninth Street. In 1909, Brooklyn United Presbyterian Church's congregation laid the cornerstone for a new church building at the corner of Pearl Road and Spokane Avenue, pictured at left. The first pastor was Rev. J.A. Mahoffy. In 1918, the congregation was led by Rev. A.V. Reid, and by 1921, Rev. W.S. Bamford was pastor. (Courtesy of Gail Hanks.)

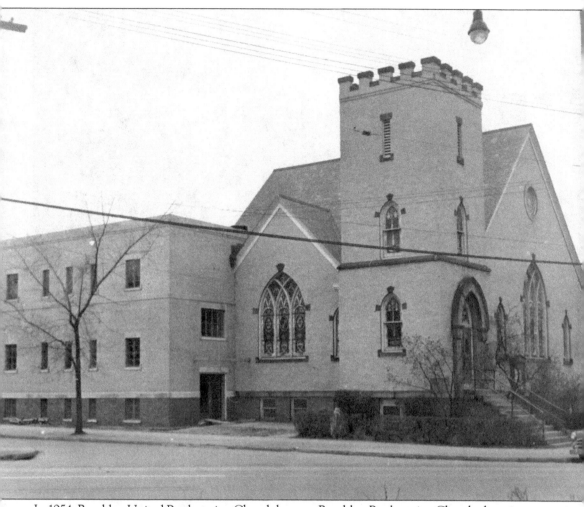

In 1954, Brooklyn United Presbyterian Church became Brooklyn Presbyterian Church, dropping "united" from its name. (Courtesy of Gail Hanks.)

Polish people started Corpus Christi Church on Stickney Avenue and Pearl Road, but the church served all nationalities. The formal blessing of the church took place on October 18, 1936. The Reverend Anthony B. Orlemanski was the pastor. This church closed in 2010, merged with Our Lady of Good Counsel, and was renamed Mary Queen of Peace Catholic Church. On June 10, 2011, Lumen Pearl Realty, LLC, purchased the former Corpus Christi Catholic Church and School buildings at 4850 Pearl Road. Pearl Academy is a tuition-free public charter school, serving students from kindergarten through eighth grade. (Courtesy of Carol Lade.)

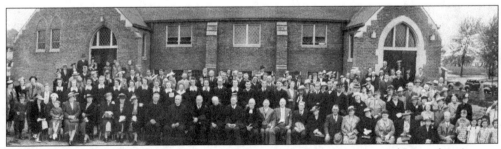

Gloria Dei Evangelical Lutheran Church on West Fifty-eighth Street and Memphis Avenue was dedicated in 1940, with the Reverend Nelson A. Miller as pastor. (Courtesy of Gloria Dei Evangelical Lutheran Church.)

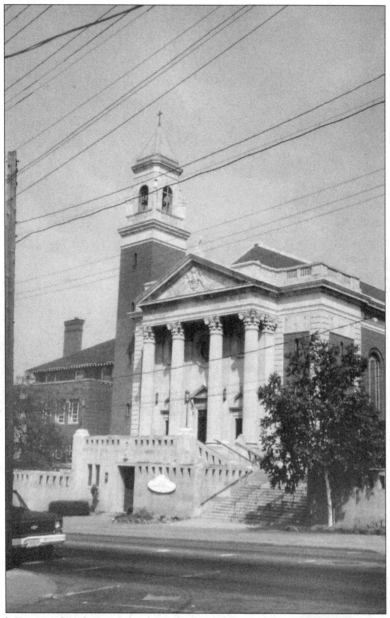

Rev. Patrick Francis Quigley was the first pastor of the Sacred Heart of Mary and said his first Mass for the congregation at a public school. Later, the home of a member and an unused cooper shop served as meeting places before the first church was erected in 1874. The growth of Sacred Heart of Mary was slow. The church was destroyed by fire on May 12, 1907. The disaster caused the site of the church to be switched to a location more central for the Catholic families in Old Brooklyn. In October 1907, a church and school structure was started on the present site. The new church and school were dedicated on August 15, 1908. Ground was broken for the present church on March 19, 1917, and at that time, the name of the church was changed from Sacred Heart of Mary to Our Lady of Good Counsel. The lower church was completed in September 1918. Our Lady of Good Counsel merged with Corpus Christi Church in 2010, and the two congregations were renamed Mary Queen of Peace Catholic Church. (Courtesy of Carol Lade.)

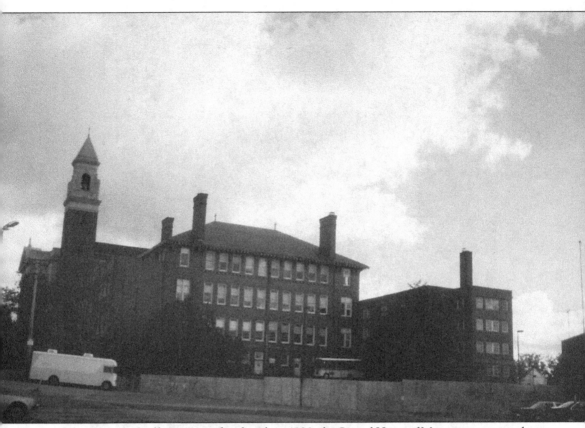

When Rev. A. Steffen came to the church in 1890, the Sacred Heart of Mary congregation began to take interest in having a parish school, and a two-room school was opened on September 3, 1894. After the church was destroyed by fire, it, as well as its school, was moved and renamed Our Lady of Good Counsel and was dedicated on August 15, 1908. Once again renamed, Mary Queen of Peace School is now a Catholic kindergarten through eighth grade school. (Courtesy of Carol Lade.)

Around 1832, some of the original founders of Brooklyn Memorial Church, located in Brooklyn Centre, decided to start their own church. The building purchased for the meeting place had been used for an academy, a wagon and paint shop, and a meeting place for the village council. The original Pearl Road Methodist church was called Brighton Methodist Episcopal Church. (Courtesy of Pearl Road United Methodist Church.)

The original Pearl Road Methodist Church was built sometime between 1895 and 1898. In February 1925, the original church was destroyed by fire. It was located where the grass lawn is in front of the present church at 4200 Pearl Road. (Courtesy of Mike Loizos.)

The original Pearl Road Methodist Church is pictured as it appeared in 1924. Note that, at one time, it was customary for the men and boys to sit on one side of the church and the women and girls on the other side. In 1884, Samuel Mower, the first regular pastor appointed to Brighton Methodist Episcopal Church, announced the end of that seating arrangement. Charles and Mary A. Gates were the first to sit together. (Courtesy of the Pearl Road United Methodist Church.)

According to Clyde Patterson and Kathryn Gasior Wilmer, authors of *Old Brooklyn New—Book 1*, published in 1979, St. Mary's on the Flats started a mission to Brighton in 1873. In October 1874, the cornerstone was laid for the church, called Sacred Heart of Mary. This church was located west of Pearl Road on Broadview Road, near the Brookmere Cemetery. In May 1907, this church burned down, and in 1909, Our Lady of Good Counsel was built.

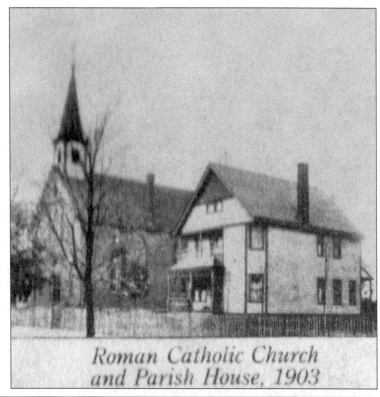

Roman Catholic Church and Parish House, 1903

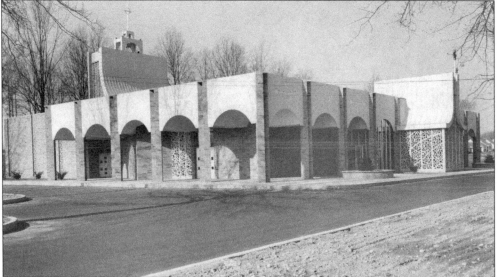

St. Leo the Great Roman Catholic Church was founded in 1948 under the pastoral leadership of Fr. Sylvester Lux. The current church building at 4940 Broadview Road was constructed in 1969. The original property extended south and was sold to the State of Ohio to allow for the construction of Interstate 480. Father Lux was eventually able to purchase some of the property back from the state, which saved the school building from having to be torn down. In appreciation of Father Lux's devotion to the parish, the school gym is named in his honor. (Courtesy of St. Leo the Great Parish.)

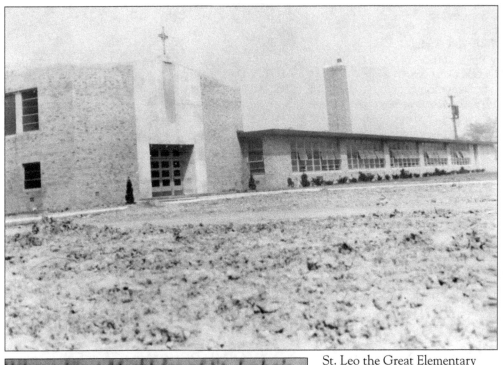

St. Leo the Great Elementary School, shown here in 1950, is a private, coed school serving 285 students, from kindergarten through eighth grade. (Courtesy of St. Leo the Great Parish.)

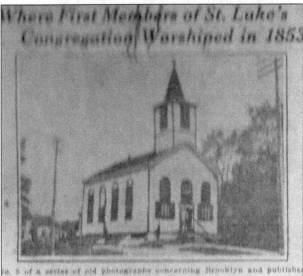

Where First Members of St. Luke's Congregation Worshiped in 1853

No. 5 of a series of old photographs concerning Brooklyn and published by The School Road Coal and Supply Co.

Here is shown a reproduction of photograph of St. Luke's church which was built on Pearl Rd. at Memphis Ave. in 1853. It was used by the congregation until 1903 when the erection of the present St. Luke's church was started on the same site.

The site was purchased for $100. When the church was dedicated in the fall of 1853 the membership totalled ?? members, that is, counting individual families. The com-munity in those days was known as Brighton, O.

The reproduction is made from a print in the souvenir book of the church, printed in 1923, when the congregation celebrated its seventieth anniversary. The book came from the library of Charles Dentzer and the print was submitted for publication by Rev. O. H. Zwilling, pastor of the church. Other old-time Brooklyn photos will be accepted gladly for publication.

On the corner of Pearl Road and Memphis Avenue was where the first members of St. Luke's congregation worshiped in 1853. The site was purchased for $100 from Dr. Parmele. The congregation used it until 1903, when the erection of the present St. Luke's Church was started on the same site. The frame church was later converted into a dwelling and moved to Devonshire Road and West Thirtieth Street, where it still stands.

St. Mark Evangelical Lutheran Church records state that, in the spring of 1893, Pastor J.J. Walker of St. Matthew Lutheran Church began to hold services in the home of Leopold Lucht at 3304 Roanoke Avenue (the house is still standing) on every fourth Sunday. One might say that Lucht's home was the cradle of St. Mark Evangelical Lutheran Church. (Courtesy of St. Mark Evangelical Lutheran Church.)

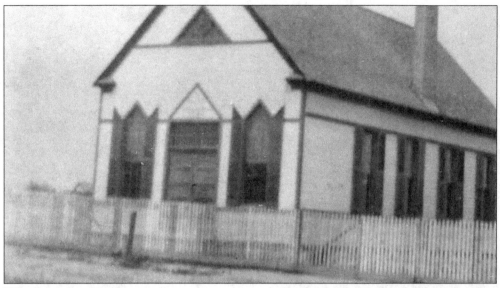

"The South Brooklyn mission drew up a contract with Charles Gates to proceed with the building of a small church. The basement was dug by hand, and there was no provision for a central heating system. The heat was to be provided with either a base burner or a potbellied stove in the cold weather. In the fall of 1893, the little church was completed. St. Mark Lutheran Mission of South Brooklyn held its first service on January 7, 1894. Pastor Henry Weseloh dedicated the church on July 18, 1894, and was assisted by Pastor H.P. Eckhardt," according to St. Mark Evangelical Lutheran Church records.

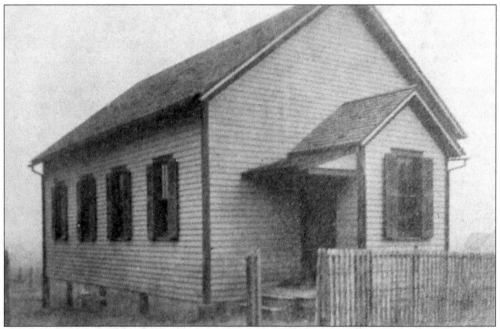

The St. Mark congregation built the small school next door to the church in July 1895. The school was dedicated in September 1895 with Pastor Eckhardt of Christ Lutheran Church officiating. The newly dedicated school of the South Brooklyn mission began in September 1895 with 25 students. (Courtesy of St. Mark Evangelical Lutheran Church.)

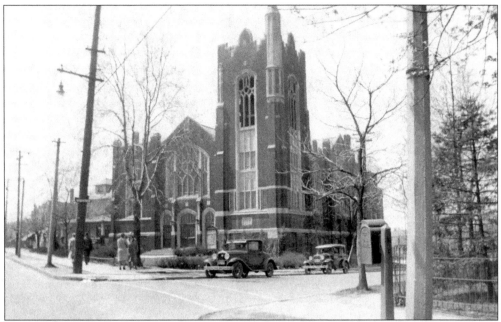

St. Mark Evangelical Lutheran Church on the corner of Pearl Road and Ardmore Avenue was dedicated on March 29, 1925. St. Mark is the oldest Lutheran congregation on the south side of the Big Creek Valley and is the fourth-oldest congregation in the Old Brooklyn neighborhood, following the Methodists, precursors of the Congregationalists and Catholics. (Courtesy of the Cleveland Public Library.)

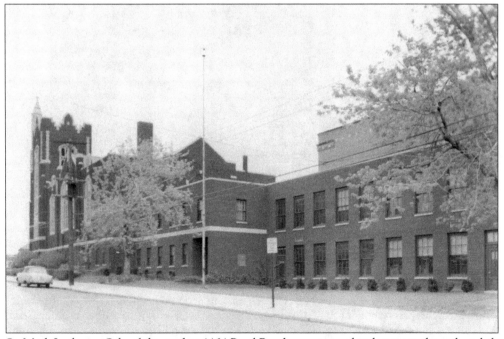

St. Mark Lutheran School, located at 4464 Pearl Road, now serves kindergarten through eighth grade. There are approximately 112 students and a faculty of nine. (Courtesy of the Cleveland Public Library.)

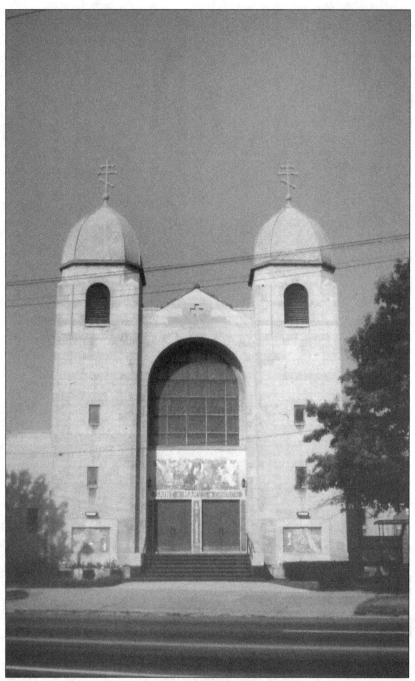

St. Mary Byzantine Catholic Church, located at 4600 State Road, was established here in 1938. The original St. Mary Byzantine Catholic Church was a rented wooden shop on the corner of West Thirty-fifth Street (present-day State Road) and Stickney Avenue. The parishioners purchased it and three additional lots and then built a rectory. A recreation hall and an auditorium, adjoining the wooden church, were constructed next. The current St. Mary Byzantine Catholic Church building was dedicated in 1950, and six years later, the former church and rectory were converted into a school and a convent. (Courtesy of Carol Lade.)

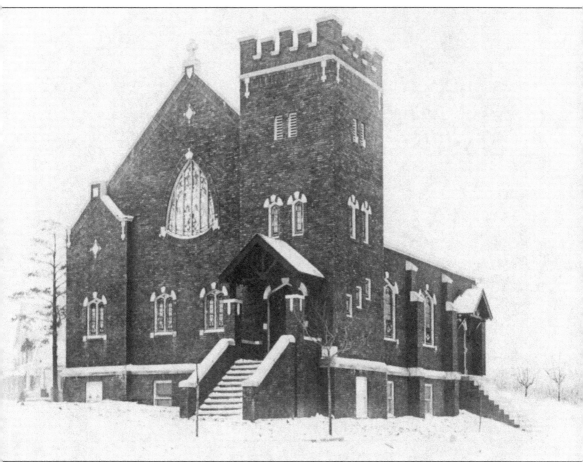

On January 1, 1912, a breakaway faction from St. Mark Evangelical Lutheran Church organized themselves as an "English" Lutheran worship group. Under the direct supervision of Rev. Charles C. Morhart, of Redeemer Lutheran Church, Cleveland, the Unity Evangelical Lutheran Church group was officially recognized as a mission on April 19, 1914. Services were held above Bader Drugstore and later in the meeting hall above the post office in Old Brooklyn. (Courtesy of Unity Evangelical Lutheran Church.)

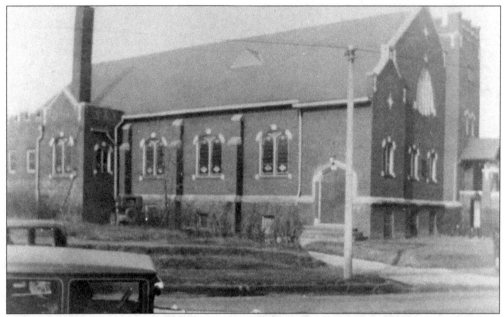

The above photograph, taken between 1927 and 1935, shows Unity Evangelical Lutheran Church. Unity continued as a mission until September 12, 1915, when Robert Gerhart Long, a recent seminary student, was selected by Rev. C.C. Morhart to be ordained and installed as Unity's first permanent pastor in residence. The mission was elevated to full church status, associated with the English district of the Missouri Synod, and became Unity Evangelical Lutheran Church. The Reverend R.G. Long served until his death in 1950. The Reverends C.H. Kenrich and W.A.W. Auping should also be credited with organization and elevation to "church" status. (Courtesy of Unity Evangelical Lutheran Church.)

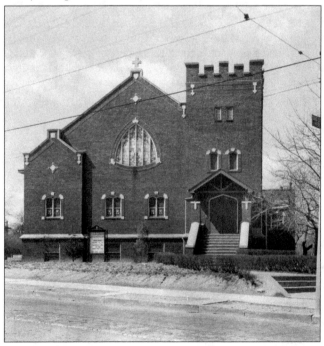

This is a c. 1935 photograph of Unity Evangelical Lutheran Church. Architects L.H. Hundertmark and L.P. Hundertmark (also a member of Unity's building committee) managed the building project for the new church. The current structure's cornerstone was laid in early 1917 and was partially completed by January 27, 1918, at which time services were held in the basement. For the next nine years, construction continued, with final completion on November 27, 1927. The expansion of an education center began in July 1956 and was completed in January 1957. (Courtesy of Unity Evangelical Lutheran Church.)

Four

RECREATION

Old Brooklyn offered many forms of recreation to its citizens. Most of the organizations, such as the Boy and Girl Scouts, YMCA and YWCA, Kiwanis and Masonic lodges, and so on, offered recreational opportunities to their members.

One of the main places where people went for recreation was Brookside Park. In this place, underneath the Brooklyn-Brighton Bridge and all the way over to the Fulton Road Bridge, one could find people of all ages participating in events such as May Day dances, fishing contests, baseball games, and swimming and visiting the Cleveland Metroparks Zoo, which was inside the park. A person could even ride an elephant on special days or watch a hot-air balloon demonstration.

Other recreational opportunities locally included bowling at several different establishments, roller-skating, dancing at dance halls, watching parades, moviegoing at three theaters, and even seeing a live performance at the theater. There was also the Estabrook Recreation Center, which housed a pool and offered a variety of exercise opportunities.

Local businessman Frank Libal owned a photography shop and often specialized in taking recreational photographs.

Of course, there were also local playgrounds where the children would gather for playtime activities.

Those who enjoyed eating together had a variety of restaurants and ice cream parlors where they could meet with friends for a meal and fellowship.

Old Brooklyn was a vibrant community with activities to meet the needs and interests of likely all of its residents, making it a great place to live, work, and play.

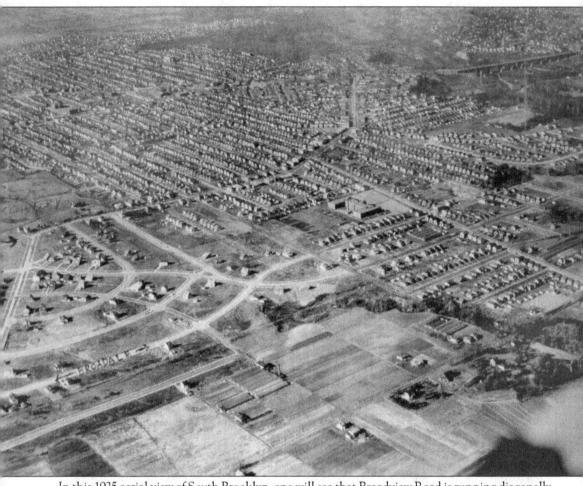

In this 1925 aerial view of South Brooklyn, one will see that Broadview Road is running diagonally across the photograph. Spring Road slants down on the right. West Schaaf slants down on the left. (Courtesy of Lorene and Richard Bowles.)

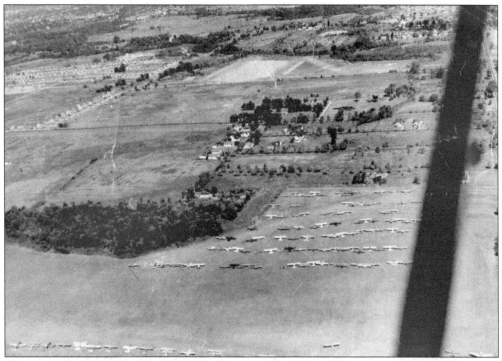

This was an aerial view of the Brooklyn Airport in the 1940s. This airport was located between Ridge and Tiedeman Roads when this area was still considered part of Brooklyn Township.

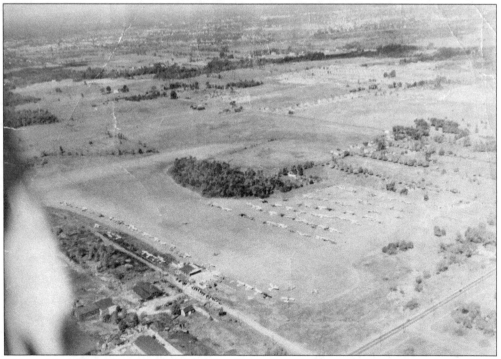

Many of the men and women from Old Brooklyn who wanted to experience flying in the 1940s did so at the Brooklyn Airport, which was managed by A.A. Walzak.

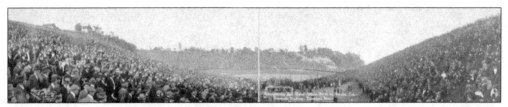

Notably the largest baseball crowd in Cleveland's history was hosted at Brookside Park, when the White Autos of Cleveland met Omaha in the World Amateur Baseball Championship. On October 10, 1915, a reported crowd of 115,000 sprawled along and below the park's northern bluff, directly west of today's Fulton Road Bridge. (Courtesy of the Library of Congress.)

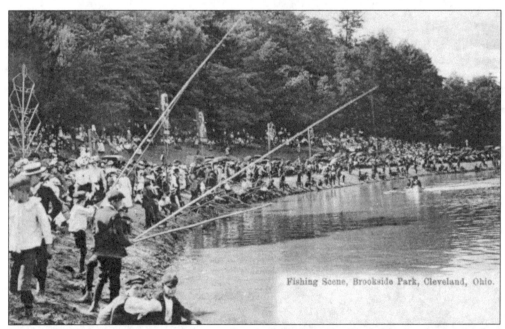

Fishing Scene, Brookside Park, Cleveland, Ohio.

This postcard shows a boys' fishing contest at Brookside Park in Cleveland, Ohio, and is postmarked 1915. It is featured in the CSU Memory Collection. (Courtesy of Special Collections, Michael Schwartz Library, Cleveland State University.)

An unidentified photographer took this picture on September 10, 1911. It is from the collection of Bruce Young, now in Cleveland State University's Michael Schwartz Library. The picture depicts a hot-air balloon in Brookside Park and the fashions of the day. (Courtesy of Special Collections, Michael Schwartz Library, Cleveland State University.)

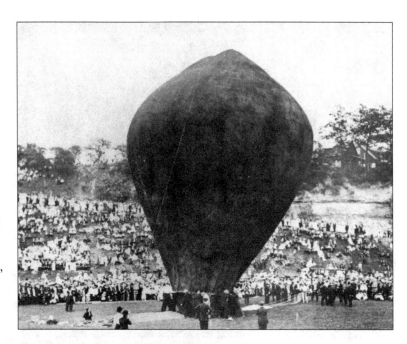

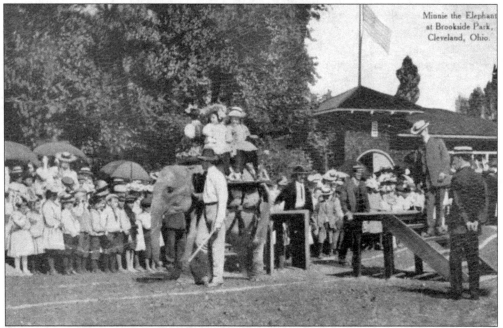

Minnie the Elephant is seen at the official dedication ceremony of Brookside Stadium on May 29, 1909. The dedication also consisted of a 15-mile race, originating in Gordon Park and finishing on the main field; other track and field competitions, such as shot put, pole vaulting, and so on, took place, involving 152 participants from 12 different gymnasiums. There was also a concert from Rossini's band, which "sent waltzes and two steps singing through the air." The thousands that lined the hillsides were seated on a "circus-like" arrangement of wooden benches that outlined the field. The children of the Cleveland City schools saved pennies to pay for the purchase of Minnie. (Courtesy of Lorene and Richard Bowles.)

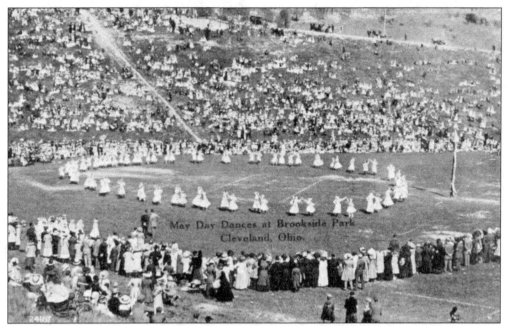

There are several postcards showing May Day dances at Brookside Park, and this May Day postcard is from the 1920s. (Courtesy of Special Collections, Michael Schwartz Library, Cleveland State University.)

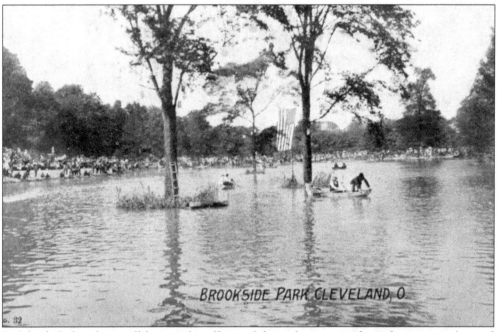

Brookside Lake, then well known for offering fishing, boating, and ice-skating, was located in Brookside Park. Brookside Park was a popular destination then and still is today. The park also had a swimming pool, the zoo, baseball diamonds, and tennis courts. (Courtesy of Jill Riegelmayer Kolodny.)

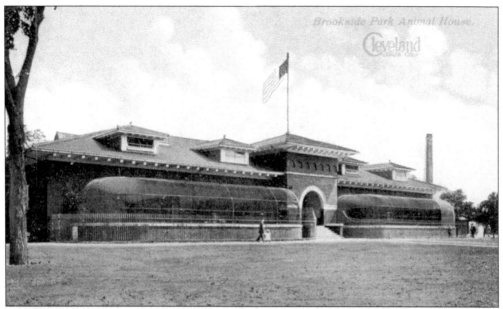

In January 1959, heavy rains and melting snow caused Big Creek to overflow, and the resulting flood wiped out the zoo's reptile collection and damaged many buildings. The zoo recovered by 1962. (Courtesy of Lorene Bowles.)

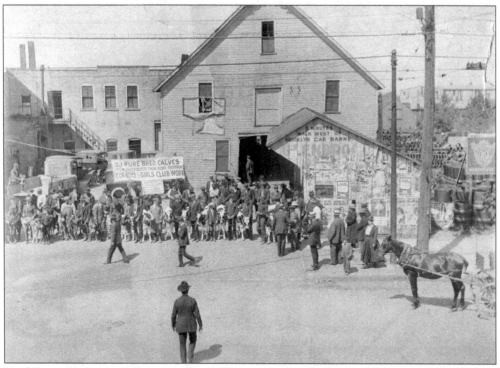

Pearl Street Savings and Trust Co., Bank of Berea, Brecksville Bank, and Chagrin Falls Banking Co. united to purchase "23 Pure Bred Calves to be distributed . . . for Boys and Girls Club Work." This had to be sometime before the Pearl Street Savings and Trust Co. was built in 1923. (Courtesy of Tom Collins.)

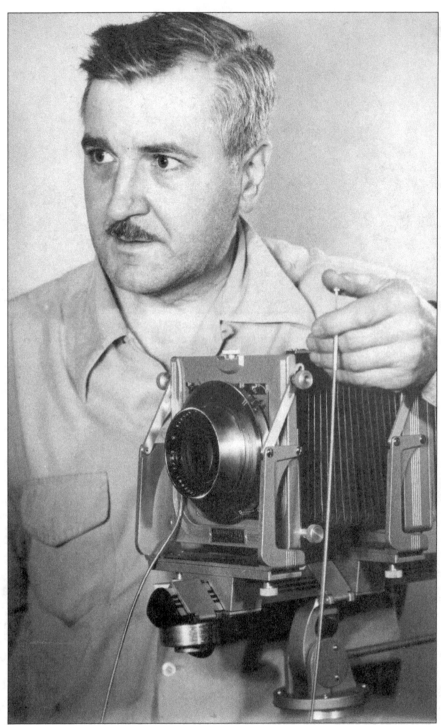

Frank Libal was South Brooklyn's neighborhood photographer and historian during the 1930s and 1940s. About 20 years after his passing, during his estate sale, the Historical Society of Old Brooklyn was able to obtain a portion of his photography collection. He and his wife, Doris, are buried in the back of Brookmere Cemetery.

Old Brooklyn photographer Frank Libal is taking a photograph of the band he played accordion with in the 1940s.

Frank and Doris Libal, seen in the center of the photograph, enjoyed evenings out at the Chatterbox Bar on Pearl Road, which was two doors down from their United Photo business.

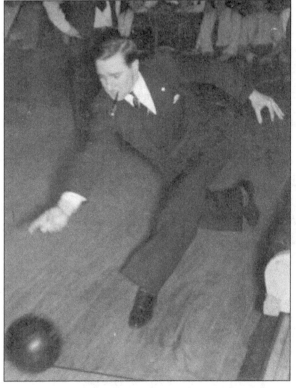

Here, Frank Libal is dressed up for bowling in the 1940s. This was a very popular form of recreation in Old Brooklyn.

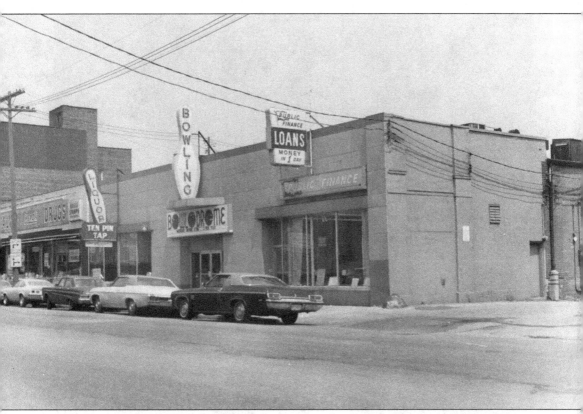

The commercial strip of 3328–3336 Broadview Road used to include the Bowlodrome Bowling Alley, pictured on May 21, 1974. The Bowlodrome burned down on January 19, 1976. The fire was so intense that it melted the bowling balls. (Courtesy of the Cleveland Public Library.)

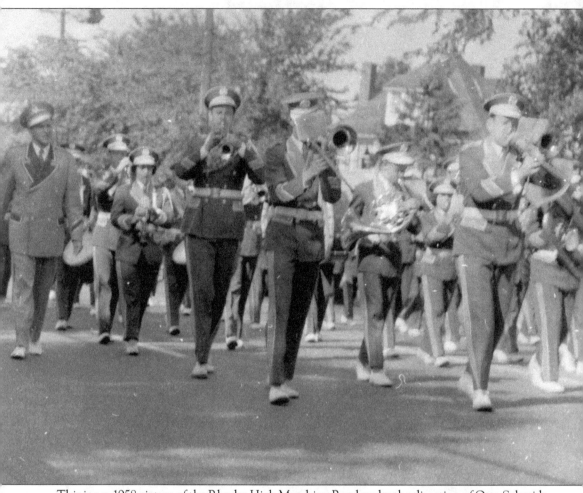

This is a c. 1958 picture of the Rhodes High Marching Band under the direction of Otto Schmidt. Tim Allport, along with the rest of the band, was marching in the Memorial Day Parade heading for the Brooklyn Heights Cemetery on Broadview Road. Tim is the person with the French horn in the middle of the picture. (Courtesy of Tim Allport.)

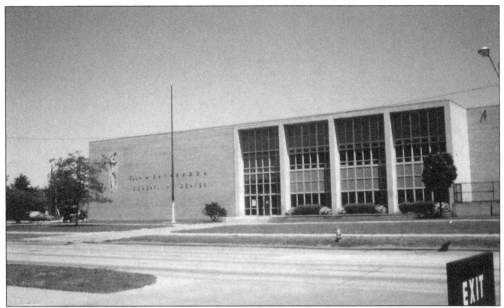

This recreation center was named after Ella M. Estabrook (née Davison), who died on January 20, 1937. She was married to Austin Estabrook, who died in 1932. They lived in the former Howard C. Gates home at 4248 West Thirty-fifth Street. The recreation center was built in 1953. (Courtesy of Carol Lade.)

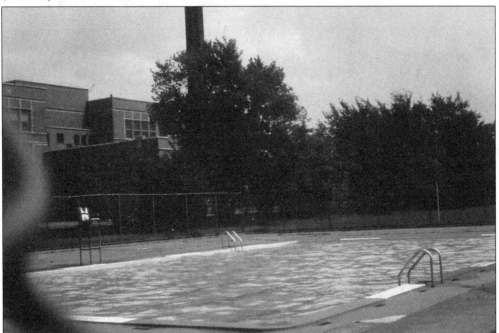

This image shows the Loew Pool, located at West Twenty-ninth Street and Oak Park Avenue, as it looked in 1983. This is one of the City of Cleveland's public pools. The pool is located at the northwest corner of the park, behind William Cullen Bryant Elementary School. The pool parking lot entrance is nearby at West Thirty-second Street and Archmere Avenue. The park also has baseball/softball diamonds, tennis courts, and a new spray park. (Courtesy of Carol Lade.)

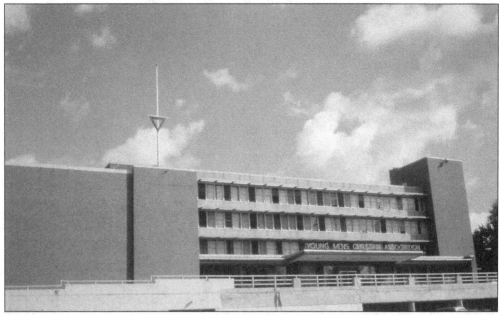

Karl Kist founded the Brooklyn branch of the YMCA in 1919. The first home was a second-floor office at 4145 Pearl Road that the YMCA shared with the editor of the *Brooklyn News*. In 1935, the YMCA leased space from the Pearl Road Methodist Church. In 1955, it moved into its present location in the newly constructed Claud Foster Building on Pearl Road. (Courtesy of Carol Lade.)

Old Brooklyn Community Theater organized and met during some of the 1980s. Members of Old Brooklyn Community Theater wanted to take over the Broadvue Theater, but they were unsuccessful. Nonetheless, they performed in a space above the theater during the years that they were in existence. (Courtesy of Carol Lade.)

The community festival, with a parade, at William Cullen Bryant School in June 1983 was the first activity in which the historical society participated. The festival's parade progressed east on Memphis Avenue toward Pearl Road. Other participants included Engine No. 42 of the Old Brooklyn Fire Department, Boy Scouts and Girl Scouts, and representatives holding signs with Old Brooklyn street names. (Courtesy of Carol Lade.)

This was the entrance sign to the Cleveland Metroparks Zoo near the Brookside Reservation in Old Brooklyn. The zoo is home to 3,300 animals of over 500 different species and covers 165 acres. In 1907, the City of Cleveland moved the zoo to its current location in Old Brooklyn. In 1916, the zoological collections were gradually moved. In October 1944, the zoo acquired a portion of Brookside Park east of Fulton Road, increasing the zoo's size an additional 110 acres. (Courtesy of Carol Lade.)

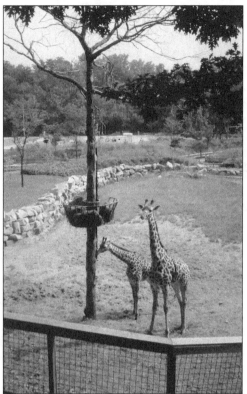

The Cleveland Metroparks Zoo giraffes are pictured here before the African Savanna area of the biothematic environments, which house animals from different regions of the world, were created. Each area is themed for the particular region of the world the animals live in. Bridgit was born at the Cleveland Metroparks Zoo in 1993. She gave birth to five offspring at the zoo, Tyra in 1998, Elvira in 2003, Mac in 2005, Jada in 2007, and Grace in 2008. (Courtesy of Carol Lade.)

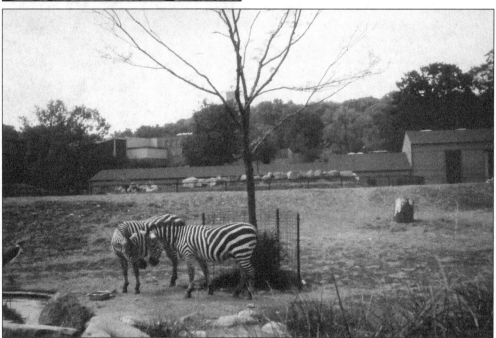

Cleveland Metroparks Zoo is home to Grant's zebras that reside in the African Savanna area of the zoo. The African Savanna, located near the park entrance, consists of several large yards featuring a variety of mammals and birds. (Courtesy of Carol Lade.)

Five

DEACONESS HOSPITAL

The Evangelical Deaconess Society established Deaconess Hospital in 1919. It was affiliated with the Evangelical church, now the United Church of Christ. The society's original mission was to recruit and train young women willing to dedicate their lives to serving their church and fellow man; however, the building of a hospital became a necessity, thus becoming the society's final mission.

The society purchased property from the Johnson family in 1919 and opened its first hospital in 1923 with 22 beds and 6 bassinets at 4229 Pearl Road. Deaconess Hospital, during its 75 years as a nonprofit hospital, grew and expanded to 316 beds and 27 bassinets. At its peak, the maternity ward had 45 bassinets. During hard financial times, the hospital's tuberculosis ward and facilities provided its main income.

Rev. Armin A. Kitterer served as hospital administrator for half a century, from 1925 until 1975, working diligently to bring the most highly qualified physicians to the hospital.

In 1955, Reverend Kitterer created the position of hospital chaplain. Rev. Oscar Zwillig, retired pastor of St. Luke's, served first as an interim until Rev. Herbert Reichert assumed his role, serving from 1956 until 1985. Following him was Rev. C. Thomas French, who served until 2000.

Family and friends of J. Milton Busch, funeral director at Busch Funeral Home in Old Brooklyn and member of the hospital's board of directors for 26 years, donated the chapel in his memory. It was open at all times to patients and visitors of all faiths.

The hospital was sold in 1994, but the company went bankrupt. Another company bought it and tried unsuccessfully to turn things around. It closed in 2003.

In 2004, the nearby MetroHealth System purchased the property. In 2007, the former hospital opened as the MetroHealth Senior Health and Wellness Center, including geriatric doctoring, long-term care beds, a hospice unit, adult day care, wellness programs, and other services for older people. The long-term care area was closed, but that space became used for the MetroHealth inpatient rehabilitation unit.

The Evangelical Deaconess Society of Cleveland purchased the Johnson property on Pearl Road on June 8, 1919. A converted Johnson house opened its doors on April 23, 1923, as Deaconess Hospital. (Courtesy of the Deaconess Foundation.)

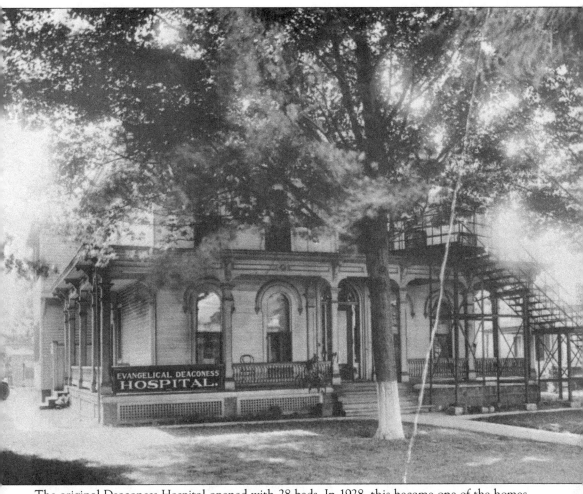

The original Deaconess Hospital opened with 28 beds. In 1928, this became one of the homes for the nurses. (Courtesy of the Deaconess Foundation.)

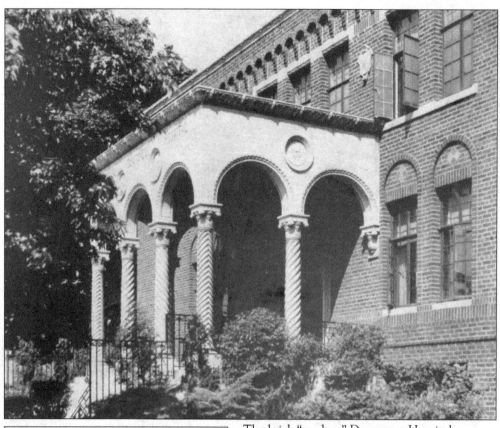

The brick "modern" Deaconess Hospital was opened October 21, 1928. As the Old Brooklyn community grew, there was a need to have a hospital. This site has now become the new MetroHealth Senior Wellness Center, one of the first wellness centers serving the needs of anyone age 55 and over. (Courtesy of the Deaconess Foundation.)

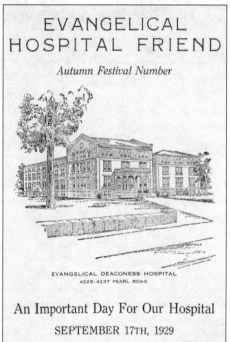

The purpose of this fall festival on September 17, 1929, was to raise funds for the nursing school, which was housed in the Johnson house in the place of the original hospital. (Courtesy of the Deaconess Foundation.)

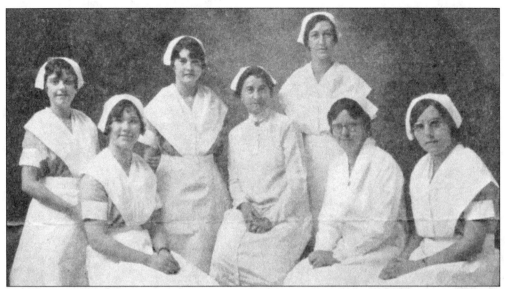

Staff and students of the 1929 training school pose for a photograph. Pictured are, from left to right, (first row) Eleanor Kintzel; Gladys Blattner, principal; Maude Melson, instructress; and Bernice Rief; (second row) Mildred Hanck, Helen Williams, and Esther Wernert. (Courtesy of the Deaconess Foundation.)

In 1928, Deaconess Hospital's first chapel was located on the terrace level in the main building. During his tenure as president of Deaconess Hospital, Reverend Kitterer and the board created the position of hospital chaplain in 1955. Three clergymen, Rev. Oscar Zwillig, Rev. Herbert Reichert, and Rev. C. Thomas French, consecutively filled this position. As chaplains they visited patients in the hospital. A new chapel was dedicated in memory of J. Milton Busch. His family and friends gave it in his memory. J. Milton Busch was the funeral director of Busch Funeral Home in Old Brooklyn and also served on the hospital's board of directors for 26 years. The first-floor chapel was open at all times to patients and visitors of all faiths. (Courtesy of the Deaconess Foundation.)

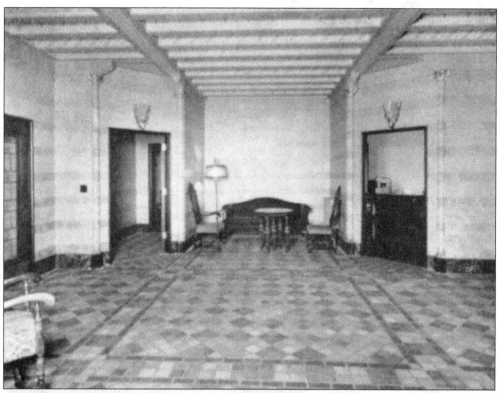

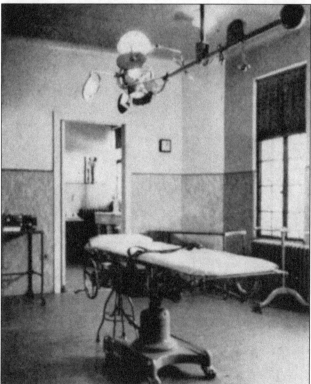

In a pamphlet produced by the Deaconess Hospital, the following was once said about the hospital: "The unique design and architecture of this foyer was the cause of frequent comment by visitors. It impresses the visiting public most favorably because of its warm and friendly appearance." (Courtesy of the Deaconess Foundation.)

This operating table cost $800 and was considered the most modern make and design. The new tables had the mechanisms to be raised and lowered, making it easier for the doctors to work on the patients. (Courtesy of the Deaconess Foundation.)

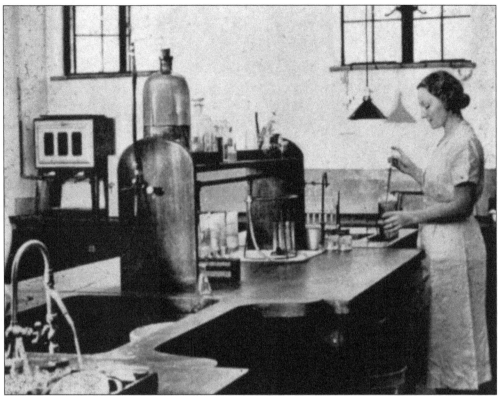

The new laboratory had added a much-needed improvement to the hospital. The various tests and examinations of blood, tissue, germs, and so on done in a hospital laboratory are of immeasurable value to the doctors in both the diagnosis and treatment of diseases. (Courtesy of the Deaconess Foundation.)

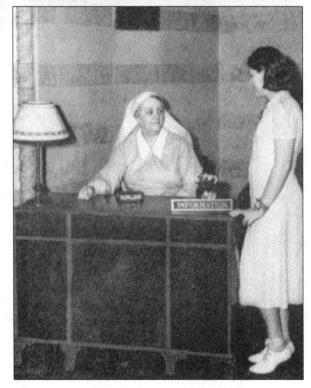

Visitors always received a friendly greeting and a courteous answer to their many inquiries. Visiting cards permitting them to visit their friends and dear ones in the hospital were obtained here. (Courtesy of the Deaconess Foundation.)

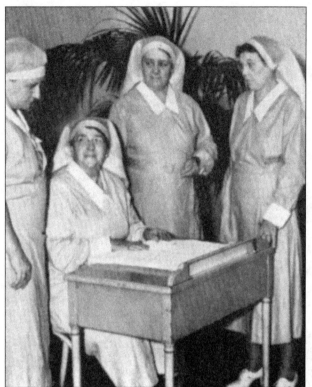

These sympathetic volunteer workers helped to bring the hospital closer to the community by maintaining the friendly attitude necessary to the success of the Deaconess Hospital institution. (Courtesy of the Deaconess Foundation.)

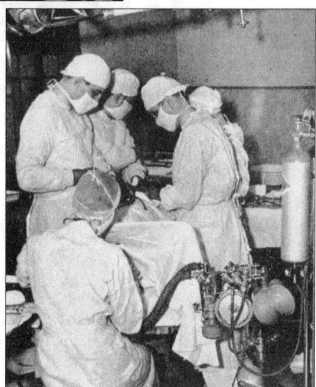

The hospital had two operating rooms equipped with all the modern instruments, which were ready at all times for the surgeon. (Courtesy of the Deaconess Foundation.)

The nose and throat division was an active department. The tonsil clinic, held every year during the school vacation period, helped hundreds of schoolchildren to better health. (Courtesy of the Deaconess Foundation.)

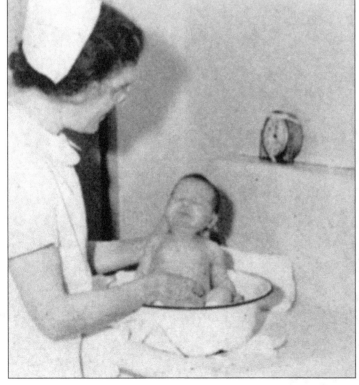

Among the many things done for infants in their daily routines was a bath, followed by a rub with antiseptic oil. Nothing that might add to the well being and comfort of these helpless little ones was left undone. (Courtesy of the Deaconess Foundation.)

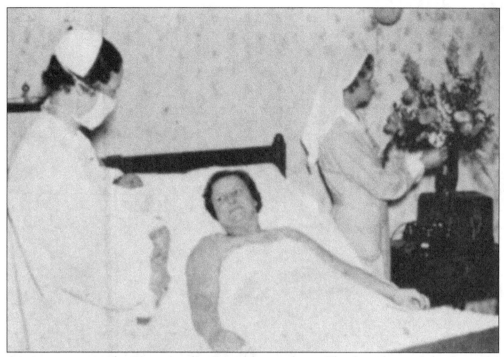

A private room in the maternity division is shown above. The furnishing of this beautiful room was a gift of the Women's Auxiliary of Evangelical Deaconess Hospital. (Courtesy of the Deaconess Foundation.)

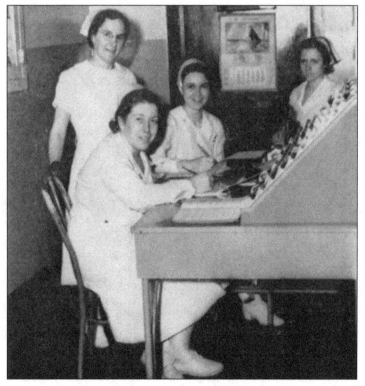

Nurses' stations were situated at convenient points in each of four divisions. It was here that visiting physicians always left orders for the patients, and the nurses charted the patient's progress for permanent record. (Courtesy of the Deaconess Foundation.)

The administrative office was an important department of the hospital. Employees of the administrative office efficiently controlled finances of the institution, under the supervision of the superintendent. (Courtesy of the Deaconess Foundation.)

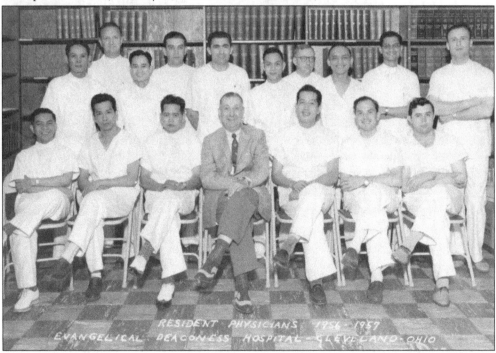

The 1956–1957 resident physicians of the Deaconess Hospital gathered for this photograph. The gentleman seated front and center, dressed in a suit and tie, was Rev. Armin A. Kitterer, who served as hospital administrator for half a century, from 1925 until 1975. He worked diligently to bring the most highly qualified physicians to the hospital. (Courtesy of the Deaconess Foundation.)

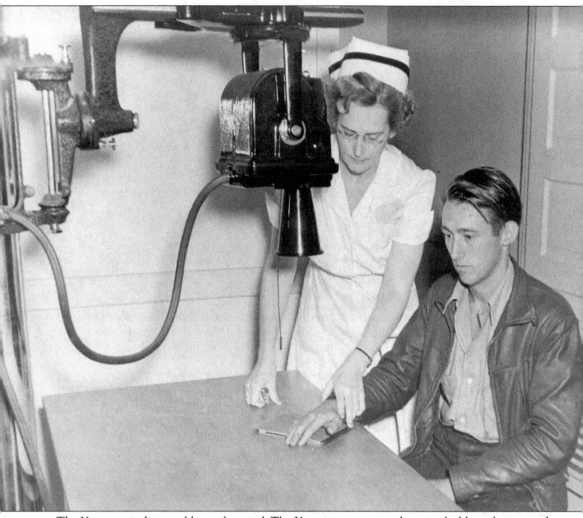

The X-ray was indispensable to a hospital. The X-ray is necessary in locating hidden ailments and in observing patient response to the physician's treatment. The nurse pictured is Janet Hastings. (Courtesy of the Deaconess Foundation.)

A student nurse is pictured bringing a meal to a patient in 1963. It was the student nurse's responsibility to care for her patient throughout the day of her clinical rotation. She was responsible for providing basic nursing care, including taking vital signs and assisting her patient with eating and bathing if necessary. (Courtesy of the Deaconess Foundation.)

The dietary staff in the Deaconess kitchen is shown here in 1963. The dietary staff was responsible for setting up the daily menu and preparing three meals daily for the hospital patients. There had to be special meals prepared for patients with specific dietary needs. The hospital had a cafeteria for the doctors and visitors, so food had to also be prepared for that place. (Courtesy of the Deaconess Foundation.)

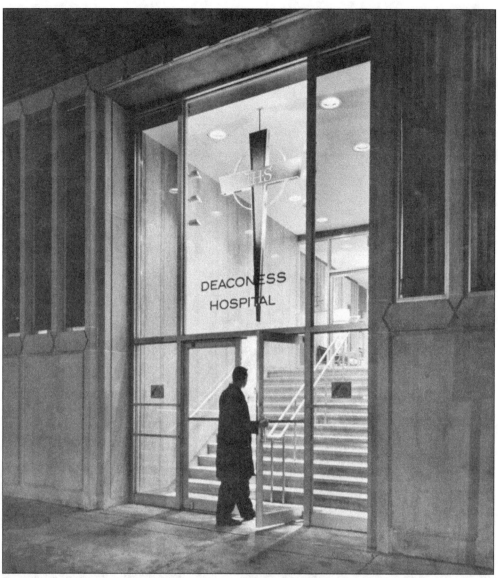

In 1963, the Deaconess main entrance was on the corner of Pearl Road. This main entrance of the hospital is no longer used, though it is still there. A parklike sitting area is at its base where people from the area can stop and take a rest. The new main entrance to the facility is on the corner of Pearl Road and Devonshire Road. (Courtesy of the Deaconess Foundation.)

Six

GREENHOUSE INDUSTRY AND BEN FRANKLIN GARDENS

South Brooklyn reached a milestone in gardening history when Gustave Ruetenik & Sons introduced greenhouse gardening in 1887. Located on Schaaf Road, their greenhouse was the oldest vegetable greenhouse in the country.

At one time, there were so many greenhouses in the Old Brooklyn area that it was commonly referred to as the "Greenhouse Capital of the United States."

Some of the greenhouses were owned by the Christensen, Drollinger, Ingham, Martin, Foote, Ruetenik, Zurowski, Cook, Meurer, Pelley, Richardson, and Rosby families.

Tomatoes and lettuce were the primary crops in most of the greenhouses. Some also grew sweet corn outside, as well as cabbage, mushrooms, and more. The Christensen family started growing a cactus in a small planter, and it eventually grew all the way to the top of the greenhouse. They had to keep cutting the top off to keep it from going through the roof. Schoolchildren sometimes had field trips just to see the cactus.

Sometime around 1960, the price of gas to heat the greenhouses became so high that greenhouse owners could not make enough money to remain open. Many of them closed. Most of the remaining greenhouses grew flowers as their primary crop but also sold shrubbery, trees, and other plants. Only a few still exist.

The Ben Franklin Gardens were originally a project of the Cleveland Public School system. The school was built in 1923 on an 11-acre plot of land, including an area dedicated to horticulture classes, gardening, and the planting of various trees and other plants. Carl Hopp, a man fondly remembered by scores of adults who learned their gardening skills from him, directed the program for many years.

Originally, children from Ben Franklin School, as well as from other schools, used the garden tracts. Later, due to high demand for garden tracts, only Ben Franklin students learned their gardening skills there. Students came twice weekly in the summer to tend their gardens with supervision. If a garden went unattended for one week, it was given to another student on the waiting list.

Due to budget cuts, the school garden program was ended in the 1970s. The Old Brooklyn Community Development Corporation then worked out a plan with the board of education, and the gardening tracts became available to adult residents.

The Cleveland Landmarks Commission designated the Ben Franklin Gardens as a Cleveland Landmark in 2004.

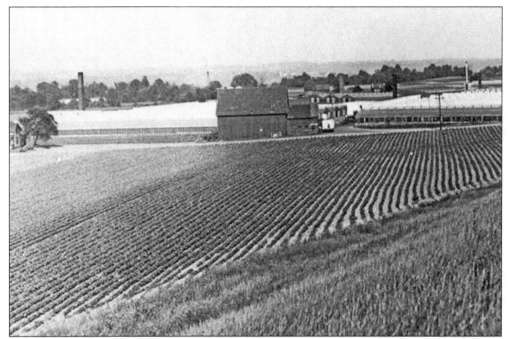

The greenhouses and farmland in the valley were below the junction of Brookpark and Schaaf Roads of Cleveland, as seen on June 15, 1936. (Courtesy of the *Cleveland Press* Collection, Michael Schwartz Library, Cleveland State University.)

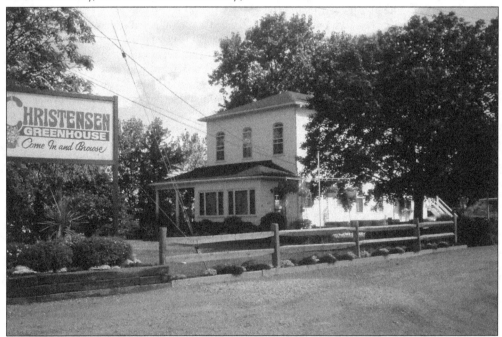

The Carl Christensen home on Jennings Road was built by Abel Fish (son of Ebenezer Fish) in 1846. Carl Christensen purchased the property in 1943. His specialty was growing lettuce and tomatoes. Dave and Esther (Christensen) Sommer took over the operation in 1977. (Courtesy of Carol Lade.)

This is a 1963 photograph of Sue Christian holding Lynn (great-granddaughter of H.E. Ingham) in front of the bunching shed, which was where the lettuce was rinsed. The Ford truck was loaded and readied for an early-morning trip to Woodland Market. (Courtesy of Sue Christian.)

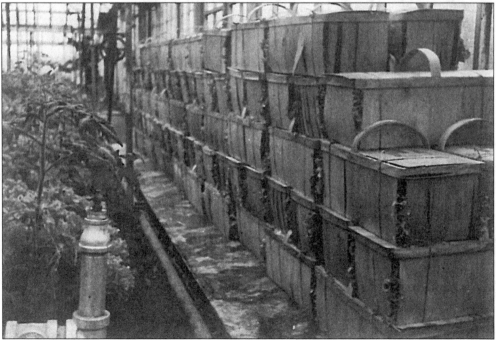

Baskets of lettuce ready for market were taken down to Central Market on Woodland Avenue. Originally, H.E. Ingham took his produce farther east to the Food Truck Terminal, likely for wider distribution, before the West Side Market. (Courtesy of Sue Christian.)

The Inghams grew radishes, carrots, tomatoes, and leaf lettuce. Although lettuce in greenhouses is generally a seasonal crop, the benefit of growing lettuce in a hothouse was that it could be grown year-round. (Courtesy of Sue Christian.)

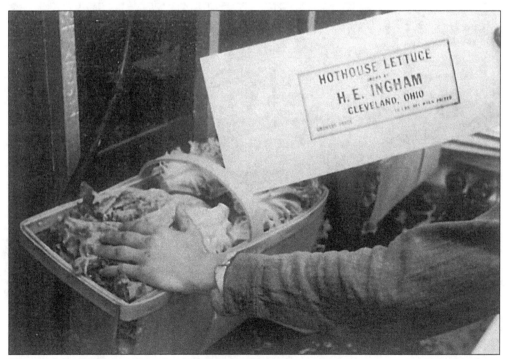

Thin wooden lids are put on the full baskets of lettuce in preparation to go to market, to keep the produce from flying out of the truck during their trip. (Courtesy of Sue Christian.)

A worker is shown here weighing a lettuce basket. Lettuce would weigh 10 pounds when packed. In 1952, two heads of lettuce could be purchased for 25¢. (Courtesy of Sue Christian.)

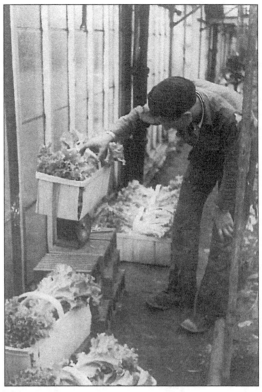

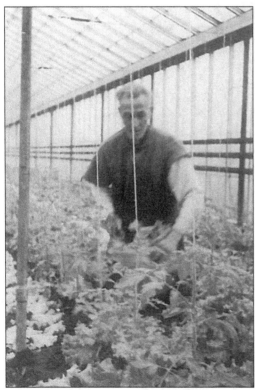

Howard Ingham is seen cutting lettuce in one of his four H.E. Ingham Greenhouses at 4264 Jennings Road. (Courtesy of Sue Christian.)

H.E. Ingham is shown here using thin wire to secure the wooden lids on the baskets to ensure that they would make the five-to-seven-mile journey to market safely. (Courtesy of Sue Christian.)

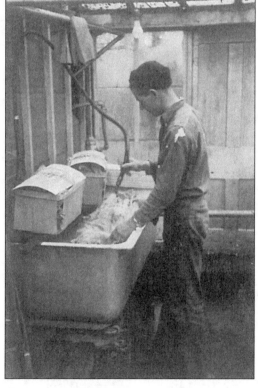

A worker is pictured here washing lettuce in the bunching shed. A bunching shed is a building for washing, bunching, and packing vegetables. This structure was also used for storing lights, mats, and cloches when these were not in use and for housing crates, empty baskets, and the like. (Courtesy of Sue Christian.)

These baskets of lettuce in the H.E. Ingham Greenhouses are ready for the employees to take to the bunching room to prepare for the trip to market. (Courtesy of Sue Christian.)

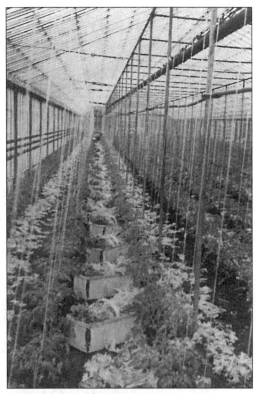

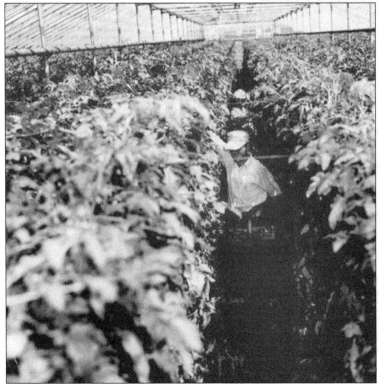

Employees are cutting tomatoes in the W.E. Martin greenhouse, located at 280 East Schaaf Road, on June 15, 1936. (Courtesy of the *Cleveland Press* Collection, Michael Schwartz Library, Cleveland State University.)

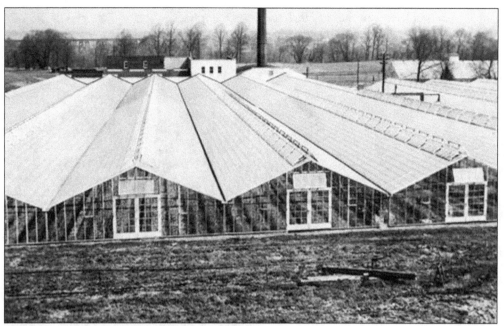

Ruetenik Gardens, located at 826 East Schaaf Road in Brooklyn Heights, was the oldest vegetable greenhouse in the United States. John Nash took this photograph on April 8, 1954. (Courtesy of the *Cleveland Press* Collection, Michael Schwartz Library, Cleveland State University.)

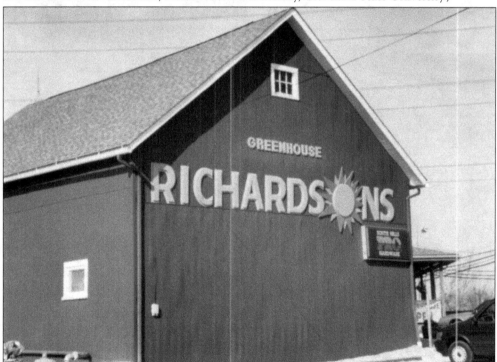

Hamilton Hutchison Richardson owned the Richardsons Farm Market originally. In 2000, grandson Neil Richardson and his son-in-law Jack Wygonski, owner of South Hills Hardware, combined the businesses under the name of South Hills Hardware. (Courtesy of Barb Richardson.)

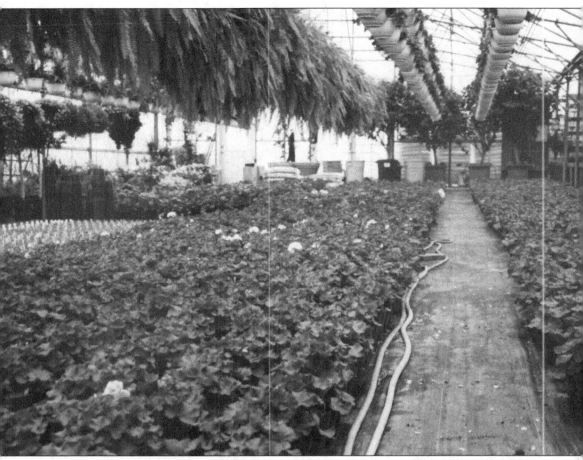

Richardsons Greenhouse started with a little stand out in front on Brookpark Road (the old Brookpark), and it moved up to the old garage Neil Richardson's grandfather had where they sold the jellies and such. Neil's grandfather built two small greenhouses on Brookpark Road. (Courtesy of Barbara Richardson.)

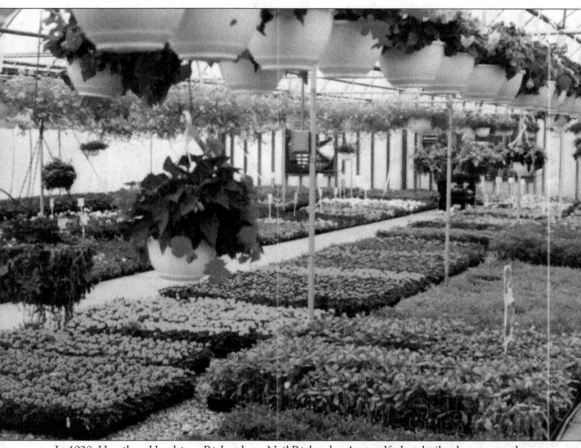

In 1928, Hamilton Hutchison Richardson, Neil Richardson's grandfather, built a larger greenhouse. (Courtesy of Barbara Richardson.)

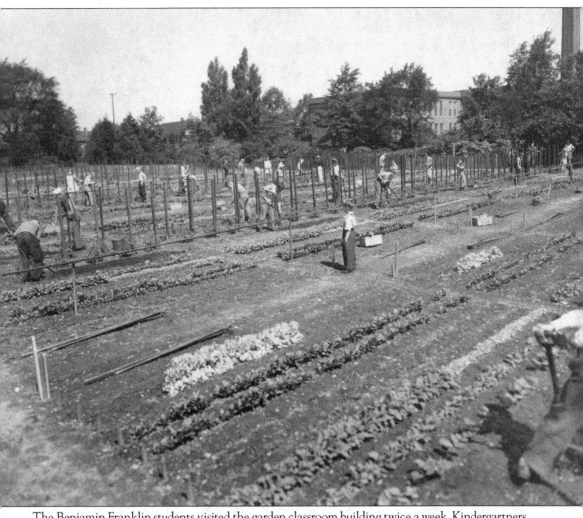

The Benjamin Franklin students visited the garden classroom building twice a week. Kindergartners tended tiny plots during the school year. In the summer, fourth through eighth graders gardened. (Courtesy of the Cleveland Public Library.)

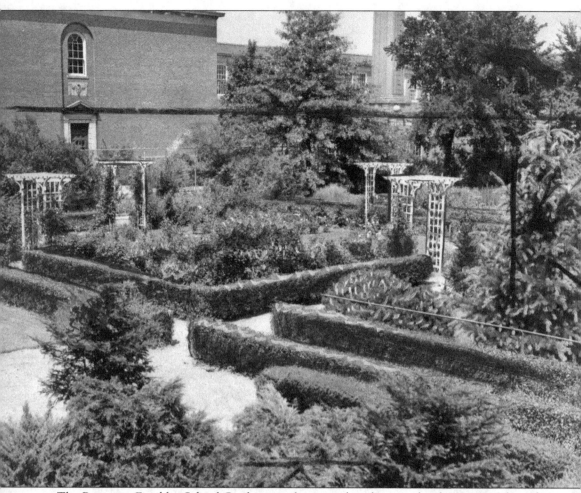

The Benjamin Franklin School Gardens are shown in this photograph taken in 1926 from the school building, facing south. To the left is a formal water garden with a wood bridge, and to the right is another formal garden with four trellis/pergola doorways. Both gardens are bordered on all four sides by hedges. (Courtesy of the Cleveland Public Library.)

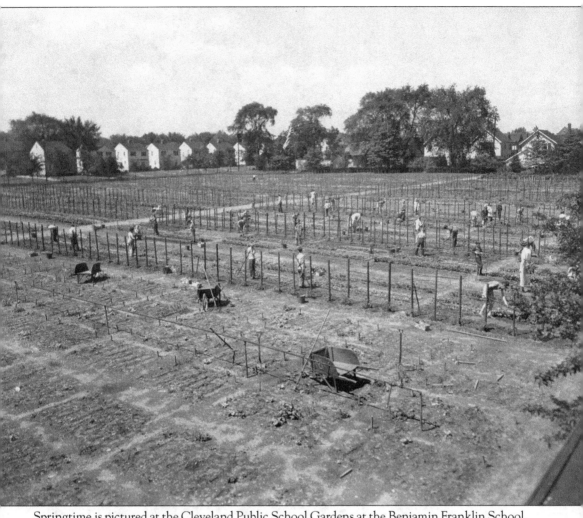

Springtime is pictured at the Cleveland Public School Gardens at the Benjamin Franklin School. Garden rules were strict. Plantings had to include something other than tomatoes, and only junior high students were allowed to grow corn or to turn on or off the sprinkler system. (Courtesy of the Cleveland Public Library.)

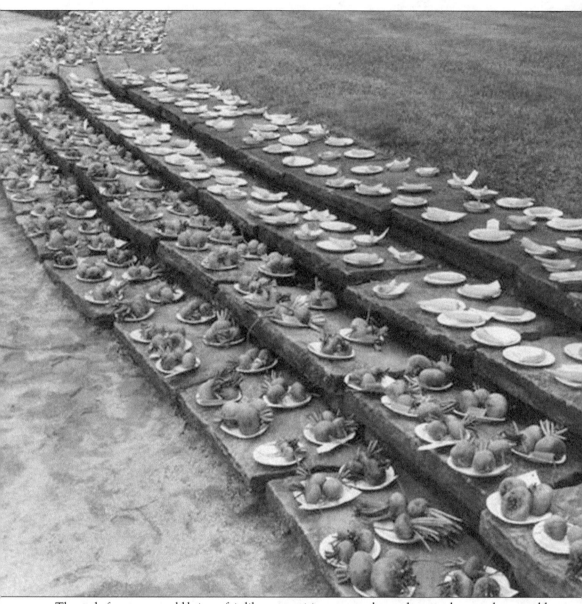

The end of summer would bring a fair-like competition among the gardeners, where students could enter their vegetables in the hope of winning a ribbon. This photograph is of beets and banana peppers on exhibit at Benjamin Franklin School Gardens on August 20, 1963. Someone from the Bureau of Visual Education of Cleveland Public Schools took this photograph. (Courtesy of the *Cleveland Press* Collection, Michael Schwartz Library, Cleveland State University.)

Seven

PRODUCERS MILK

One of the most notable companies in Old Brooklyn's history was the Producers Milk Company. In 1921, the *Plain Dealer* reported that the six-year-old Producers Milk Company had purchased land for its plant from J.W. Van De Roe.

Producers was the last local dairy that used horse-drawn carriages for its home-delivery routes. There were still 20 horses on 18 daily milk wagon runs in 1952. At that time, Producers also had a fleet of trucks.

Before the electric refrigerator, most people had their milk delivered by the milkman and stored it in their icebox, with ice supplied by the iceman.

Producers dairy was located right in Old Brooklyn on State Road at the corner of Schiller Avenue. Behind the dairy, one could find the garage for the delivery wagons and the stables for the horses.

As mentioned many times by those interviewed for *Speaking of Old Brooklyn . . .*, the horses knew their routes almost as well as the drivers. In fact, people stated that one could see the deliveryman with his carrier holding milk for several houses, and while he would stop at each house with his carrier, the horse would go on along by itself to the place where the driver next needed to fill his carrier for another few houses. One person remembered a driver's name, Barney, and the horse's name, Buttercup. An Old Brooklyn man, Harry Metzgar, who lived on West Twenty-second Street off Valley Road, cared for the horses.

People would come to Producers Milk Company for ice cream cones and other treats. They also could come during the week for regular lunch and dinner food. Producers was also the founder and owner of the Dairy-Dell stores, convenience food stores similar to those of today by other names. Producers, including 22 Dairy-Dell stores, was sold in 1979 to Oberlin Farms Dairy, Inc., but lives on in memories and these photographs.

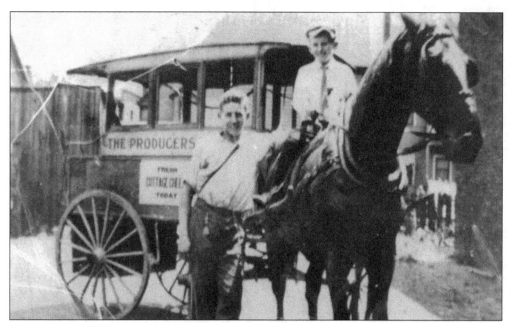

A Producers cart and horse and two boys are shown in this photograph taken in 1918. The company offered many items on the cart because wives were at home and, in 1918, not every family had an automobile. Also refrigeration was not what it is today. Items beside milk were buttermilk, butter, cottage cheese, juice, meats, and cheese; the cart probably did not carry ice cream or bread. (Courtesy of Steve Shroka.)

John Hummel, pictured here on the left, was the vice president of Producers Milk Company and head of marketing. Hummel and his friends posed for this photograph in 1926. (Courtesy of Steve Shroka.)

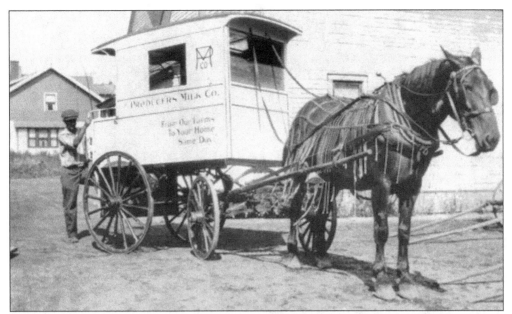

Same-day delivery was a convenience in 1926 because few people had an automobile, most women stayed home, and refrigeration was not what it is today, with many people having small iceboxes. There was a fleet of carts that served Old Brooklyn. (Courtesy of Steve Shroka.)

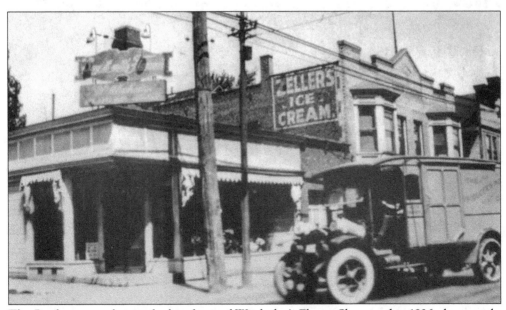

The Producers truck is parked in front of Witthuhn's Florist Shop in this 1926 photograph. Please note the sign on top of the store urging shoppers to "Say it with flowers." (Courtesy of Steve Shroka.)

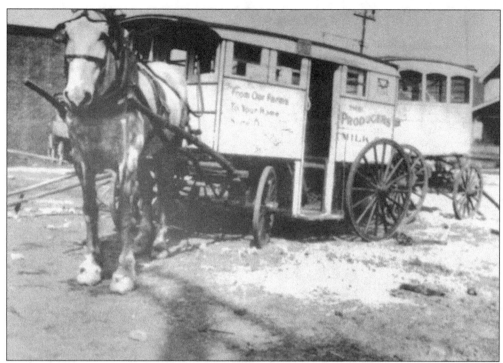

An old Producers horse-drawn cart is pictured here in 1928. The milk was delivered by cart year-round, always early in the day. This was particularly important in the summer, when the morning temperatures were cooler, to avoid spoiling the milk. (Courtesy of Steve Shroka.)

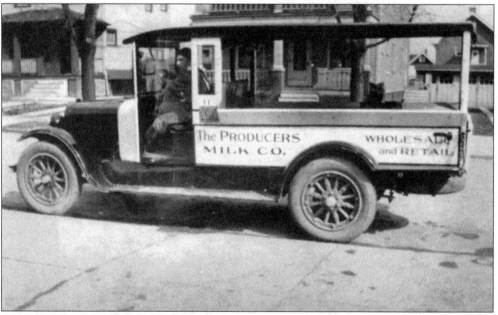

An old Producers truck, delivering to local retailers, is pictured on the street in 1928. There were many stores that sold Producers products in the neighborhood. By the 1950s and 1960s, there were 20 to 25 Dairy-Dell stores, which reached into other neighborhoods surrounding Old Brooklyn. (Courtesy of Steve Shroka.)

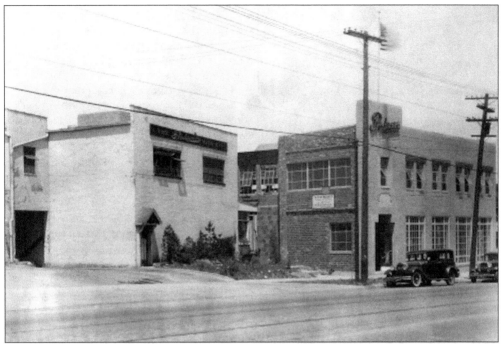

The Producers Building is pictured here as viewed from State Road in 1934. In more recent years, Producers was surrounded by St. Mary Byzantine Catholic Church, Brooklyn Heights Cemetery, Eileen's Beauty Shop, and the Hillcrest Tavern. (Courtesy of Steve Shroka.)

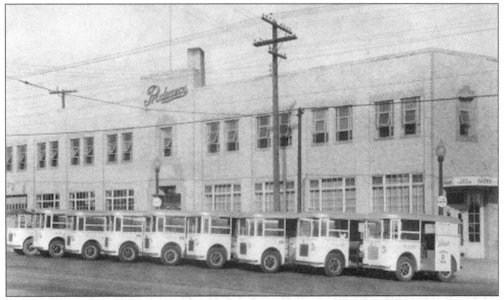

The Producers Milk Company delivery fleet is pictured here in 1935. Although these newer trucks had better refrigeration, held more products, could go faster, and perform better in bad weather, many of the drivers of the horse carts complained that the new trucks were actually more work. The horses had the routes memorized, and the driver could deliver to two or three houses before going back to the cart because the horses would walk to the next houses by themselves. The drivers had to go back each and every time to move the truck. (Courtesy of Steve Shroka.)

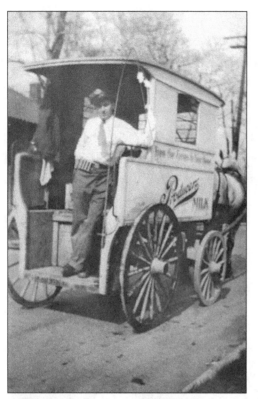

Producers continued to deliver products by horse and cart, as made evident by this photograph of a driver in 1935. As time progressed, the horse carts made deliveries closer to the plant, and the trucks delivered to the farther distances. Please note the coin changer on the driver's belt. Customers paid cash only at that time, and most of the items cost less than a dollar. (Courtesy of Steve Shroka.)

This Producers delivery driver is working his route in the affluent South Hills section of the Old Brooklyn neighborhood in 1935. On average, two to four quarts would be delivered per home, although the quantity varied depending on how many children lived in the home. (Courtesy of Steve Shroka.)

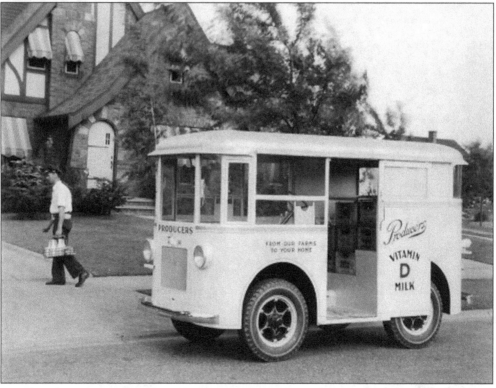

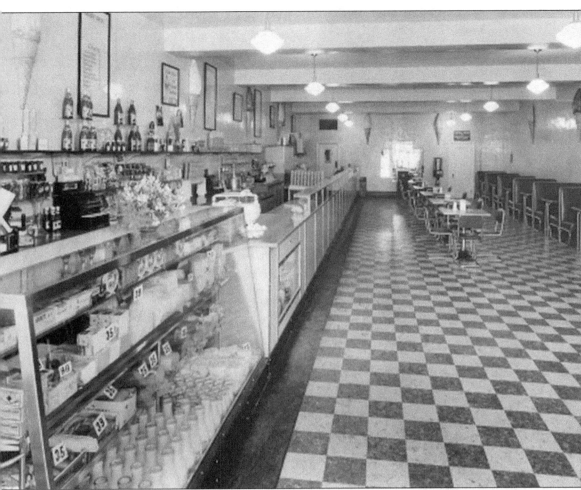

The interior of a Dairy-Dell shop is pictured here in 1937. Dairy-Dell was a chain of delicatessens that were owned by Producers. The shops sold cold meats, cheese, potato salad, chip dip, and all dairy products, and everyone stood in line for hand-packed ice cream cones, sundaes, sodas, banana splits, and hand-packed quarts and pints of ice cream. They were open from 8:00 a.m. to 11:00 p.m. On Sundays, when Mass let out from St. Mary Church, across the street, people would fill Dairy-Dell on the Producers Milk Company site for a meal or a treat. (Courtesy of Steve Shroka.)

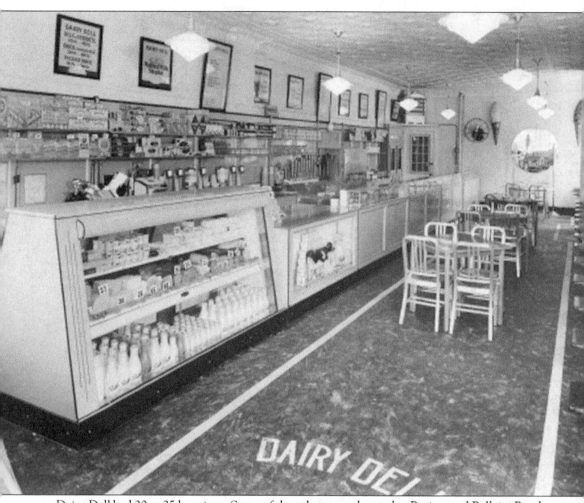

Dairy-Dell had 20 to 25 locations. Some of the others were located at Puritas and Bellaire Roads, Eightieth Street and Detroit Road, Pearl and Ridge Roads, Memphis Avenue, Ridge Road, State Road south of Brookpark, and Brunswick. (Courtesy of Steve Shroka.)

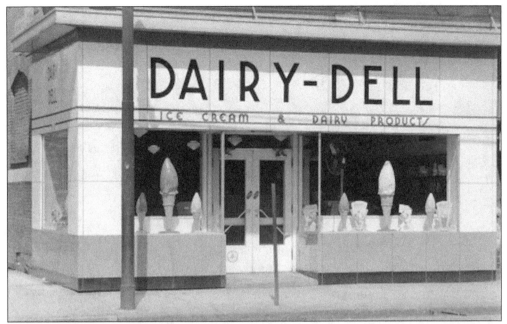

All Dairy-Dell storefronts were identically branded. They served about 20 flavors of ice cream that cost 5¢ a dip in the 1960s. Two other favorites from Dairy-Dell were the chip dip and cottage cheese. (Courtesy of Steve Shroka.)

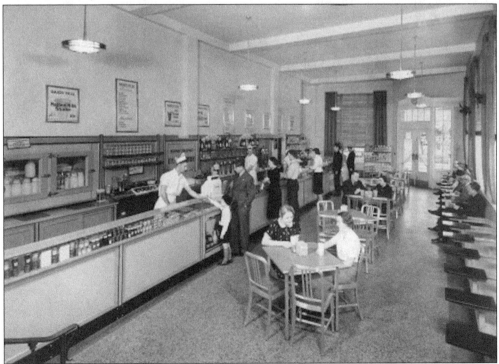

In the 1960s, Dairy-Dell also served breakfast and lunch. The shops had a cook, and many people ate meals there. Specials of the day could have included macaroni and cheese, stuffed peppers, and homemade soups. (Courtesy of Steve Shroka.)

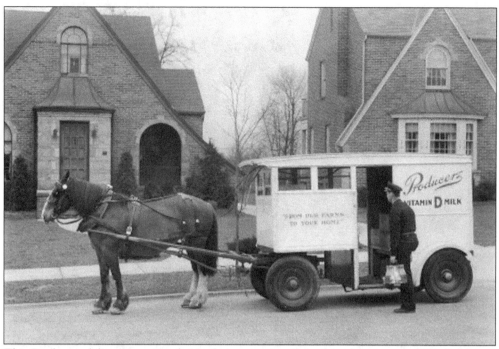

This Producers deliveryman in a horse-drawn cart is pictured in the street in 1938. Producers sold Vitavim, which came in a brown bottle, in addition to vitamin D milk, chocolate milk, and buttermilk. (Courtesy of Steve Shroka.)

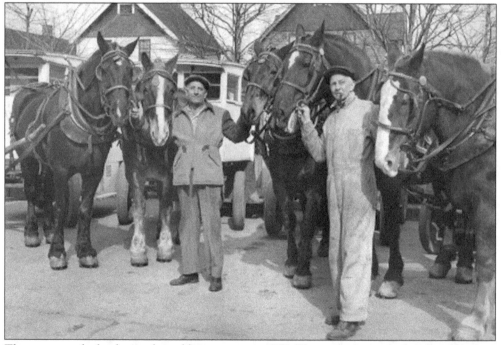

These men worked either in the stables or garage in 1953. The men who worked in the milk plant also wore a similar outfit. Producers Milk Company also had an ice cream plant. The workhorses loved sugar cubes. (Courtesy of Steve Shroka.)

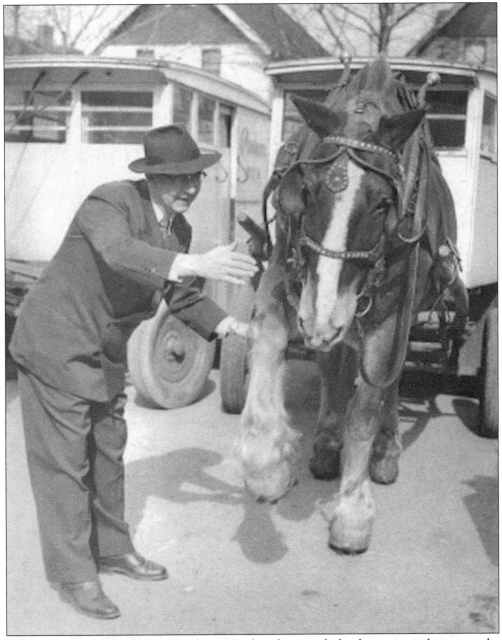

Bill Stann was the president of Producers. In this photograph, he demonstrates how tame the horses were. (Courtesy of Steve Shroka.)

Quart bottles are pictured; Producers Milk Company also sold pints and half pints, which were used at schools. (Courtesy of Steve Shroka.)

Eight

PEARL STREET SAVINGS AND TRUST CO.

On the lower level of the Johnson House Hotel, the Pearl Street Savings and Trust Co. opened its offices in the 1890s and stayed there until 1923, when the bank temporarily moved to the opposite corner of Broadview and Pearl Roads while it demolished the Johnson House Hotel and started construction of the current bank building that bears the Pearl Street Savings and Trust Co. name on its facade.

Of notable interest in its construction were the designers Benjamin Hubbel and W. Dominick Benes and architect Antonio DiNardo. Both Hubbel and Benes were designers of major Cleveland buildings, including the West Side Market and the Cleveland Museum of Art.

DiNardo was a talented artist in watercolor and oil painting, chiaroscuro, and a renderer in both pen and ink and pencil. He became a designer in the office of Hubbel and Benes and designed the Pearl Street Savings and Trust Co., several churches, and the McGregor Home for the Aged and made the original plans for the Belgian Village on Fairhill Road. In 1936, he designed the experimental modern structure for the Great Lakes Exposition—the Transportation Building. His paintings were frequently exhibited in the Cleveland May Show, and some have been purchased for the Cleveland Museum's permanent collection. In 1924, he published a volume of lithographs titled *Farmhouses, Small Chateaux and Country Churches in France.*

The Pearl Street Savings and Trust Co. Building has been occupied by numerous different banks over the years, and, in 2014, it is a beautiful but vacant structure.

After the Johnson House Hotel was demolished, work began on what would be the foundation and the basement of the future Pearl Street Savings and Trust Co. by contractors John Grant and Son Builders. These images, taken August 21, 1922, by the architectural firm Hubbel and Benes, detail the expanse of the property, located at 4175 Pearl and Broadview Roads. (Both, courtesy of Tom Collins.)

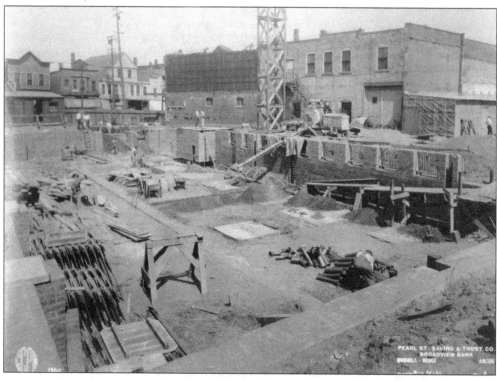

Taking advantage of the season, workers moved quickly to build the safe inside the Pearl Street Savings and Trust Co., as seen at right on August 30, 1922. By early October, scaffolding for the entire structure was in place, complete with modern heating elements. If one looks carefully, just below the first-floor scaffolding, the temporary location of the Pearl Street Savings and Trust Co. is visible on the opposite corner, as well as the Marshall Drug Co. (Both, courtesy of Tom Collins.)

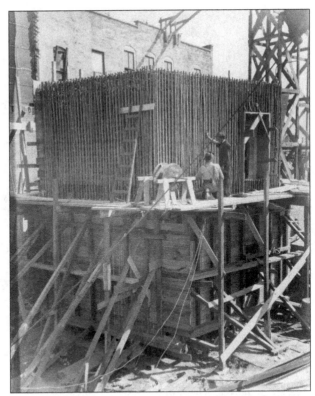

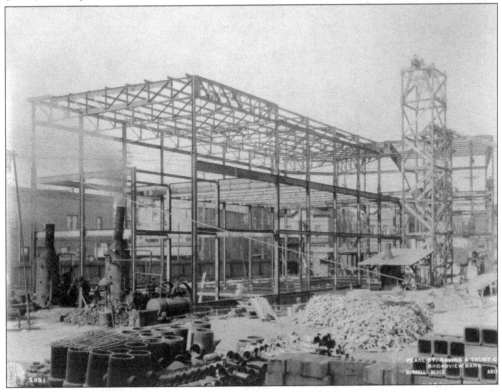

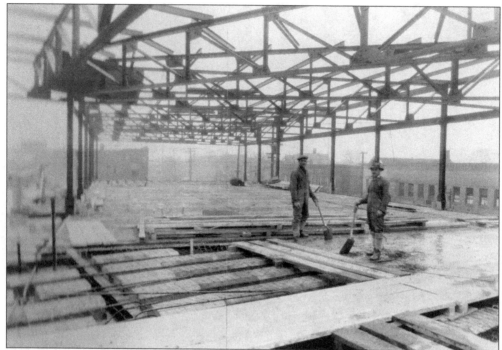

By November 14, 1922, construction was under way on the second floor of the bank. Workers, pictured above, are seen laying the concrete subflooring. Progress slowed down in December with the holiday season and the onset of snow. Shown below, the worksite is photographed on December 30, 1922, without a person in sight. (Both, courtesy of Tom Collins.)

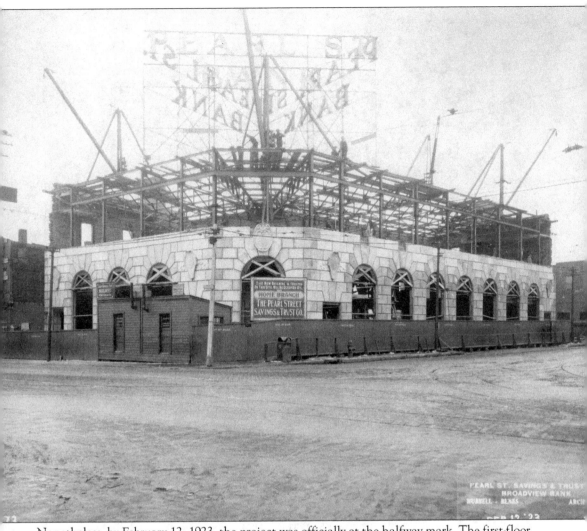

Nonetheless, by February 12, 1923, the project was officially at the halfway mark. The first-floor facade was complete, and the memorable Pearl Street Savings and Trust Co. sign was erected, hovering above the scaffolding. (Courtesy of Tom Collins.)

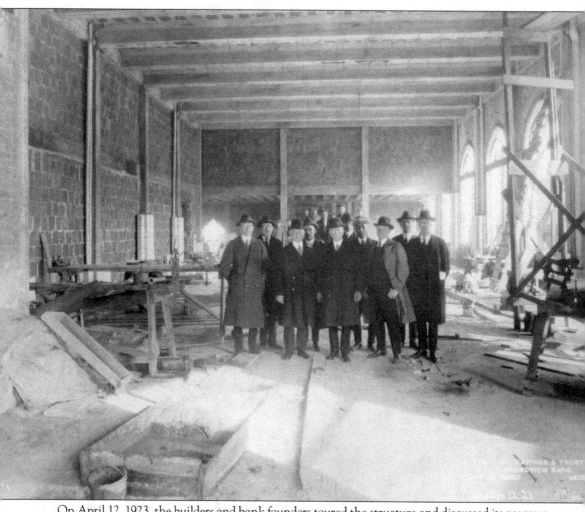

On April 12, 1923, the builders and bank founders toured the structure and discussed its progress, the likely completion time frame, and its interior design choices. (Courtesy of Tom Collins.)

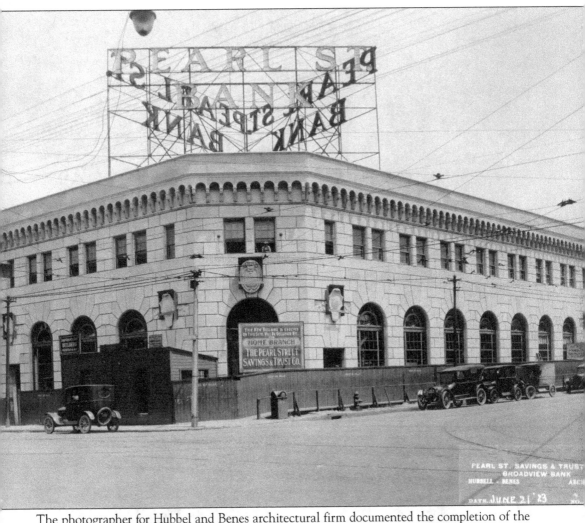

The photographer for Hubbel and Benes architectural firm documented the completion of the Pearl Street Savings and Trust Co. bank on June 21, 1923. (Courtesy of Tom Collins.)

By September 22, 1923, the focus had shifted primarily to the building's interior. Marble teller walls and columns were crafted into place, and an ornate plaster ceiling design was beautifully executed at the direction of Antonio DiNardo. (Both, courtesy of Tom Collins.)

By 1924, Cleveland Trust was the sixth-largest bank in the United States. Following the Pearl Street Savings and Trust Co. Building's completion, this bank and location merged with Cleveland Trust. Such a merger enabled the bank to weather the Great Depression and survive a severe loan default by the city in the 1970s. The image above shows Ruth Hanks Stebner standing in front of the Cleveland Trust. Both images portray Cleveland Trust during the bank's heyday in the 1950s; it was a staple in an active and vibrant community. (Both, courtesy of Tom Collins.)

Visit us at
arcadiapublishing.com

CPSIA information can be obtained
at www.ICGtesting.com
Printed in the USA
BVHW012146110719
553267BV00007B/10/P